Peter Fraser Material

Steidl

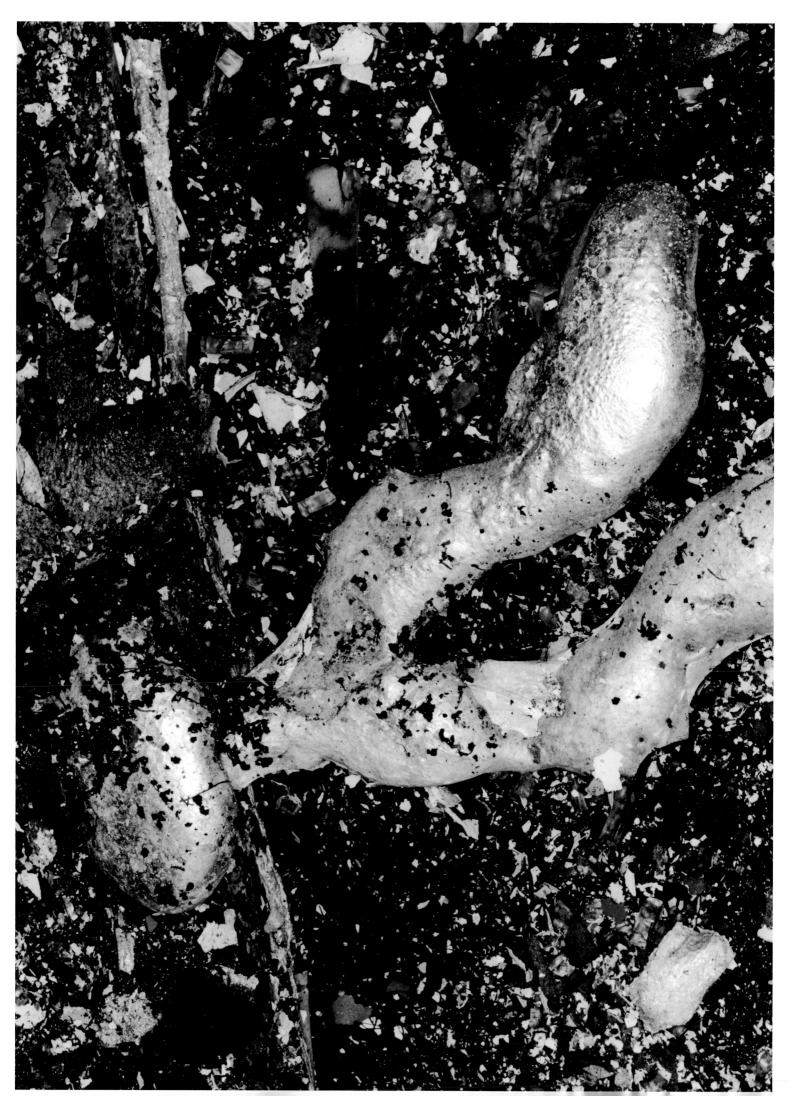

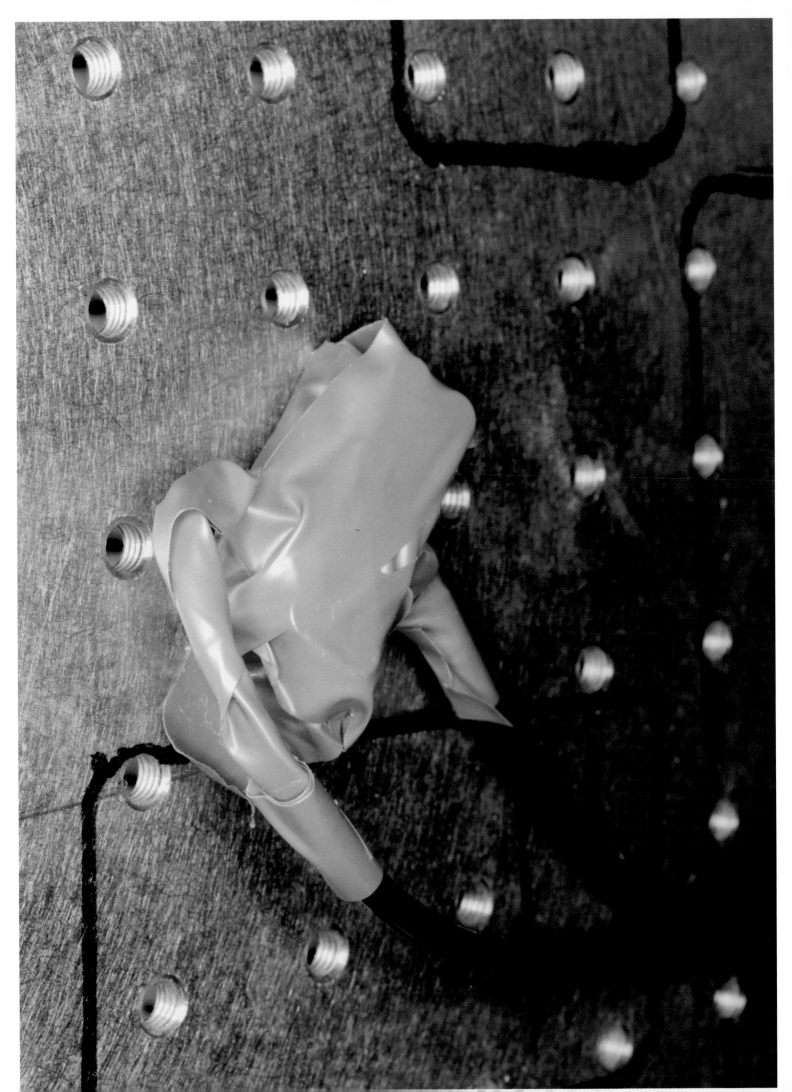

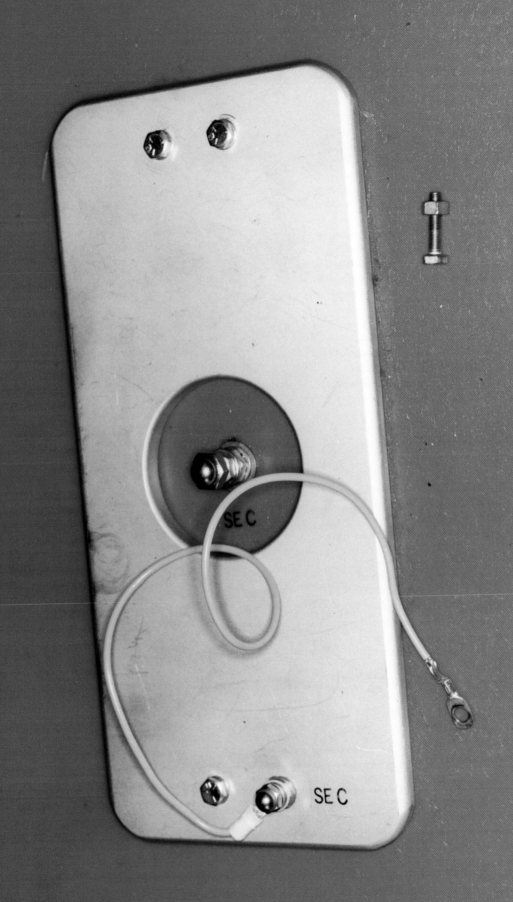

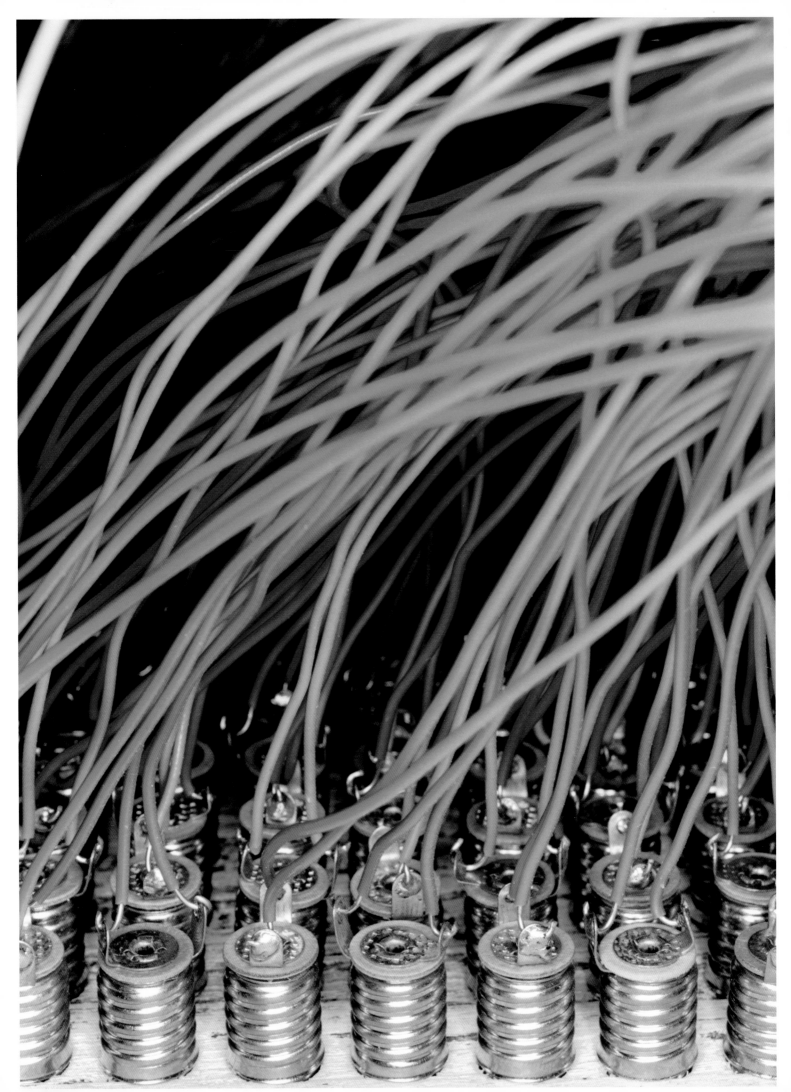

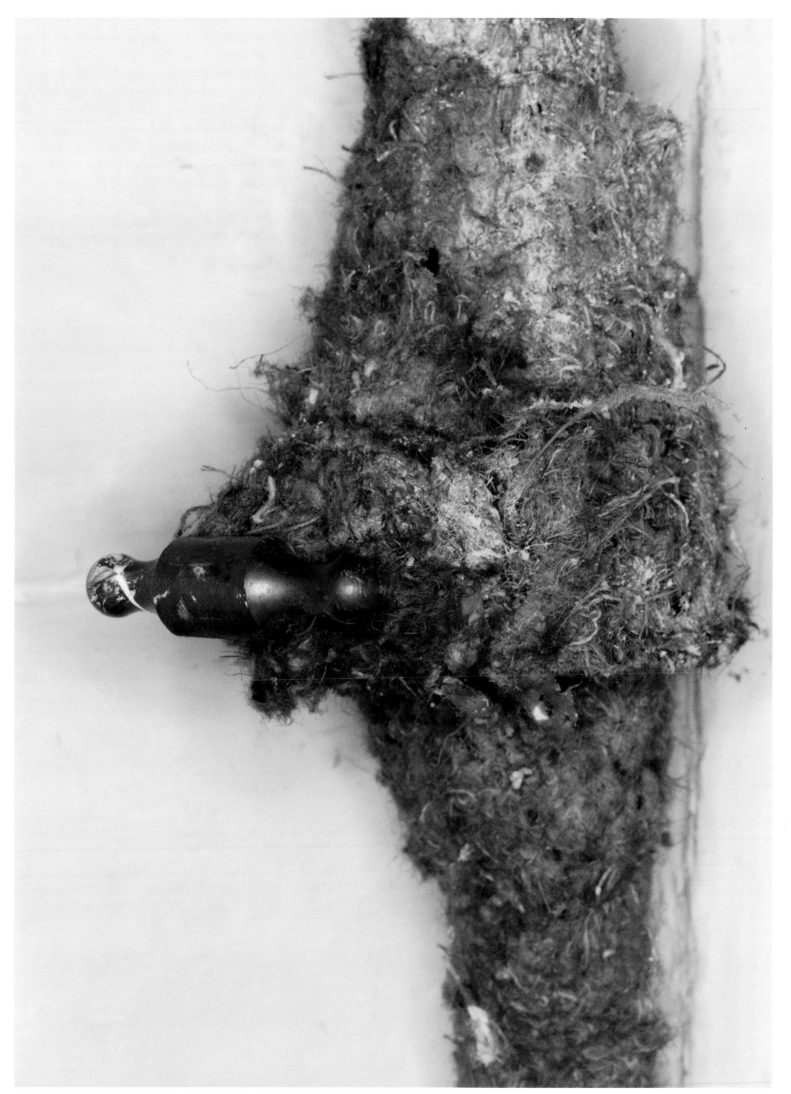

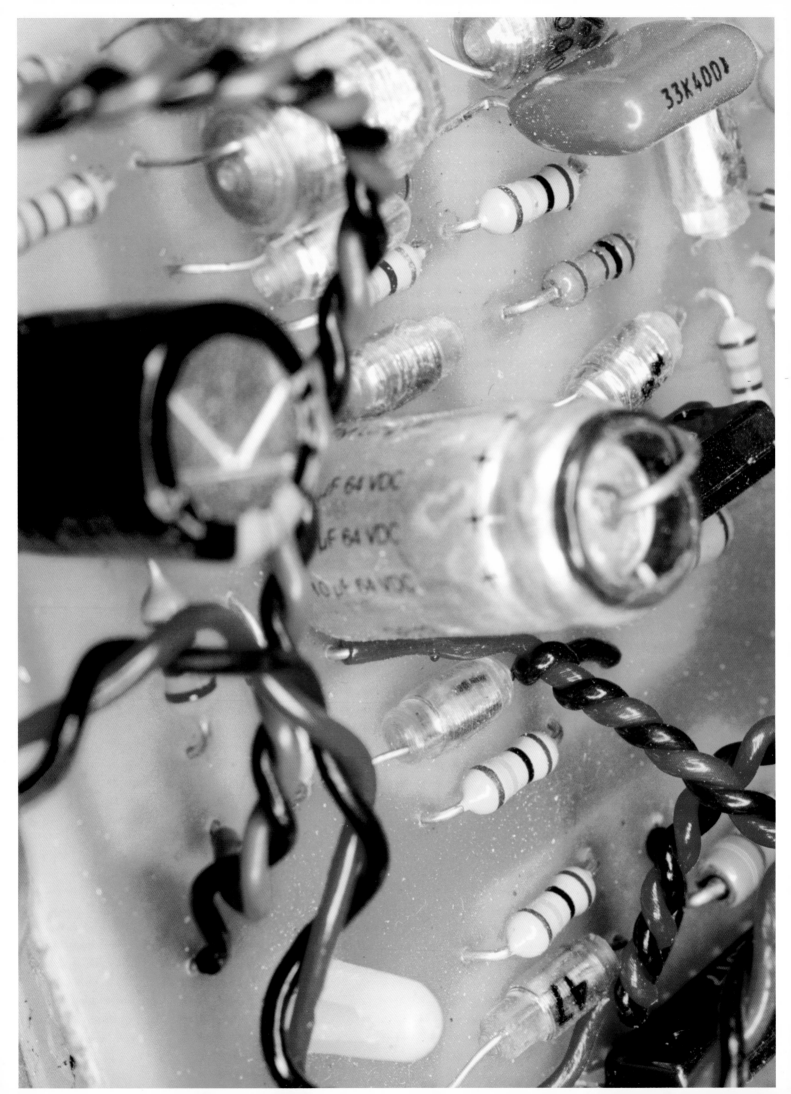

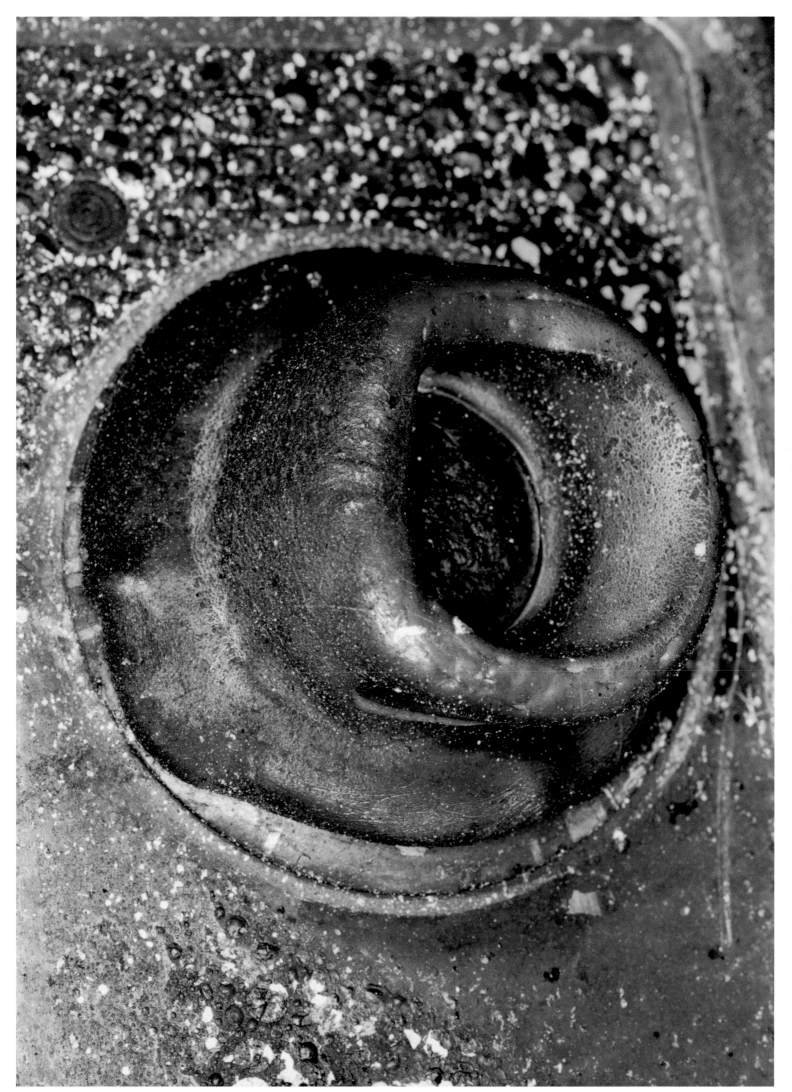

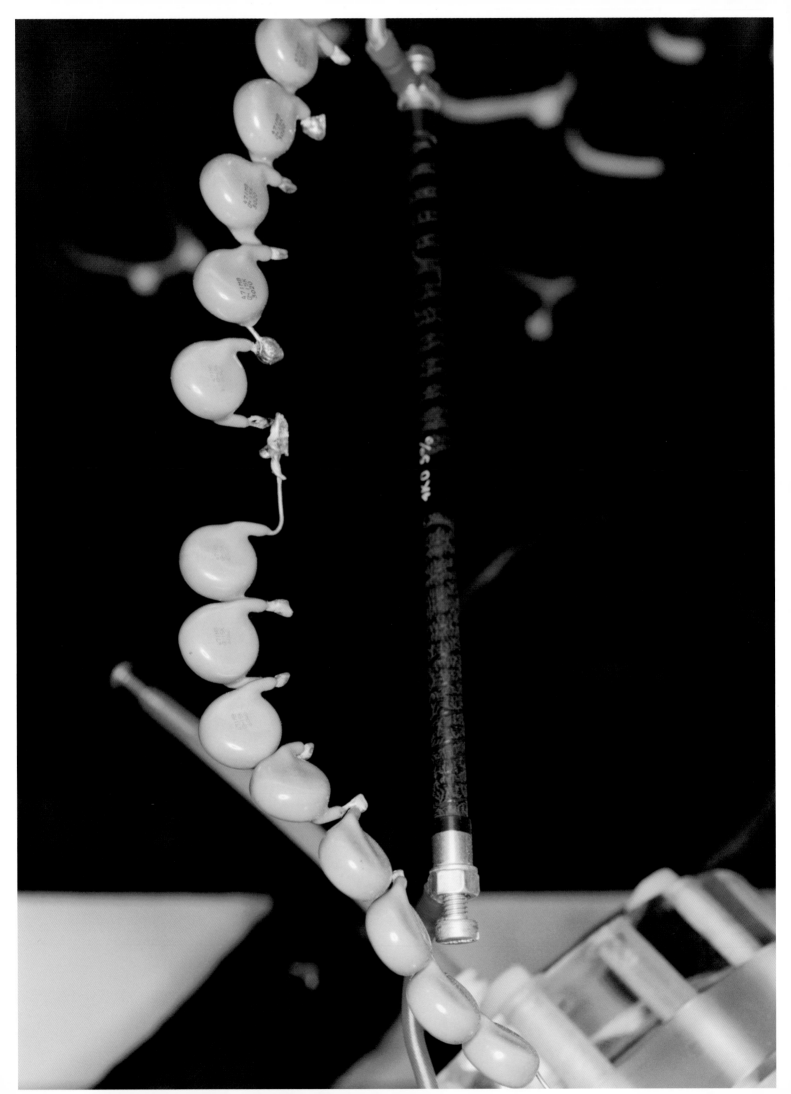

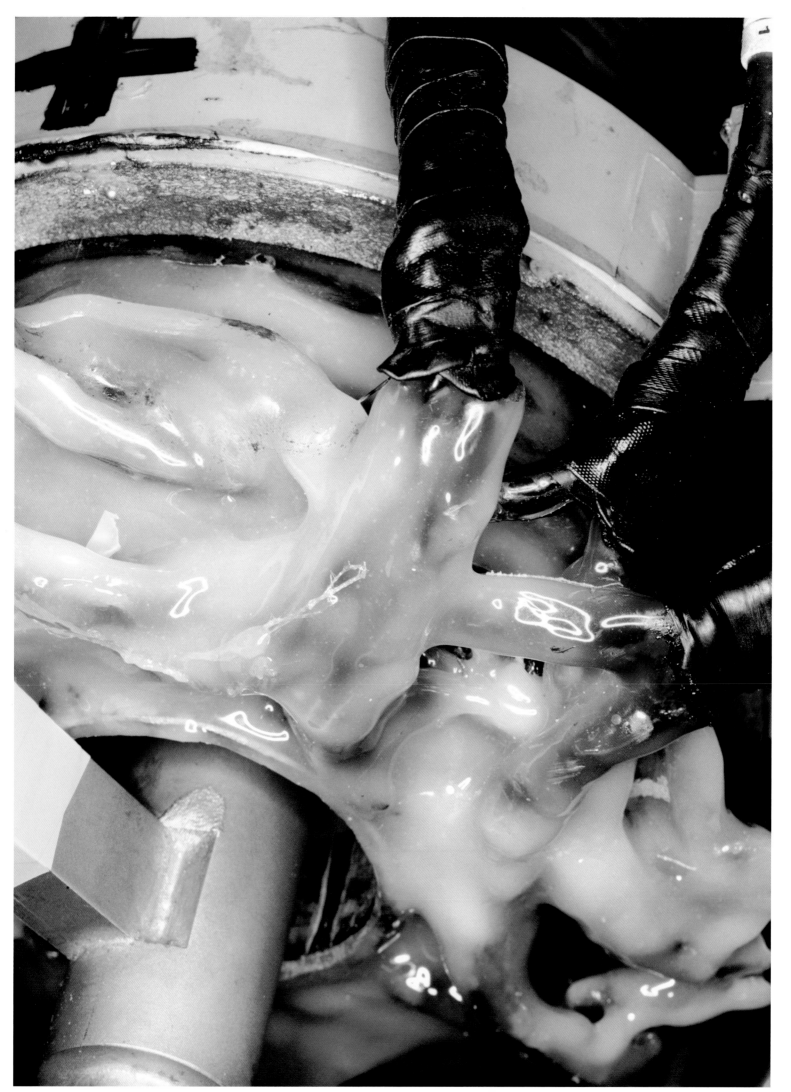

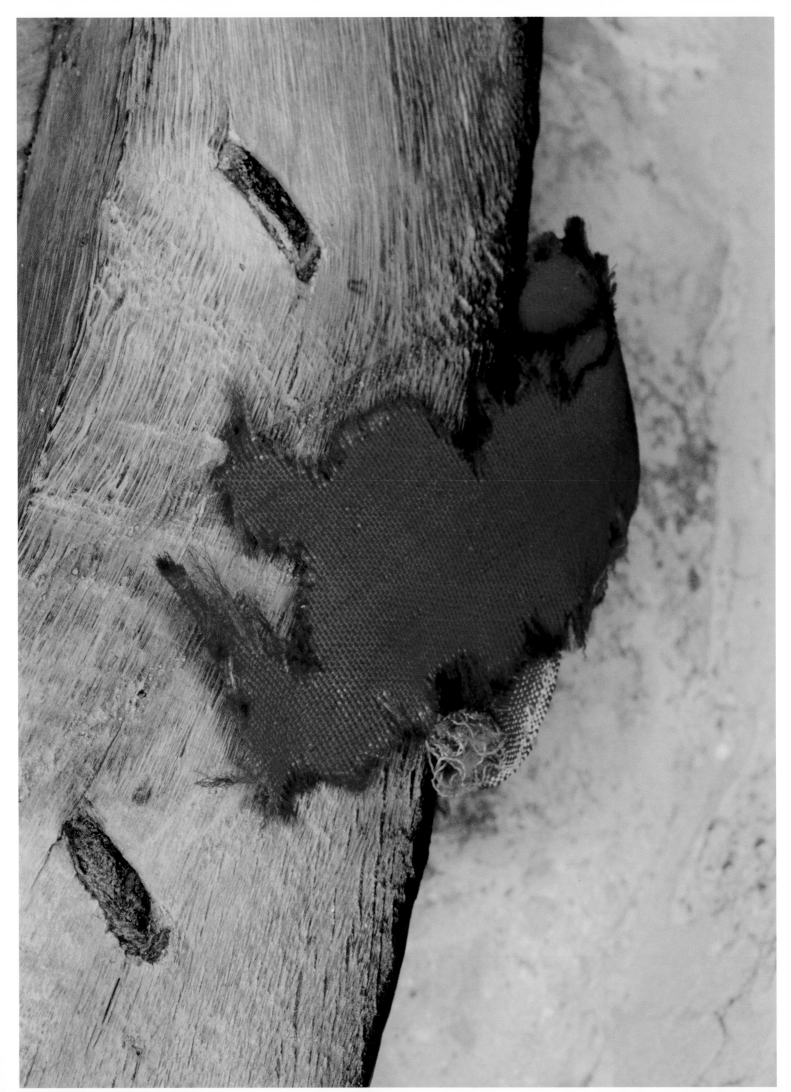

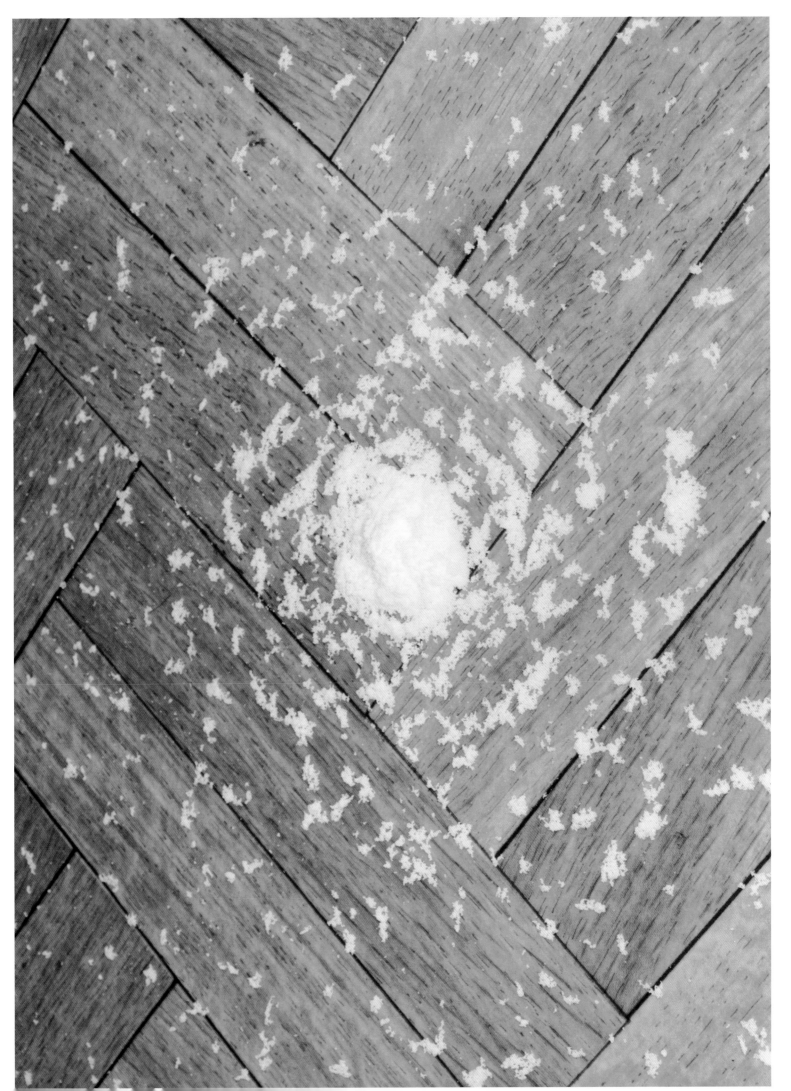

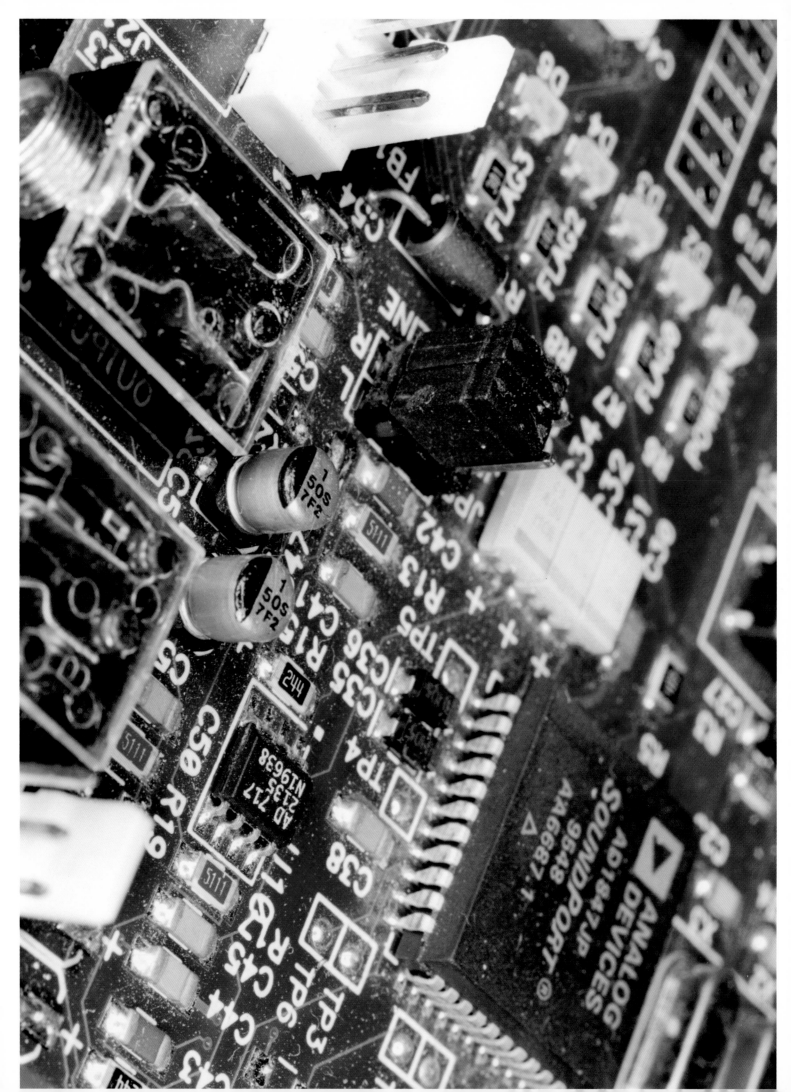

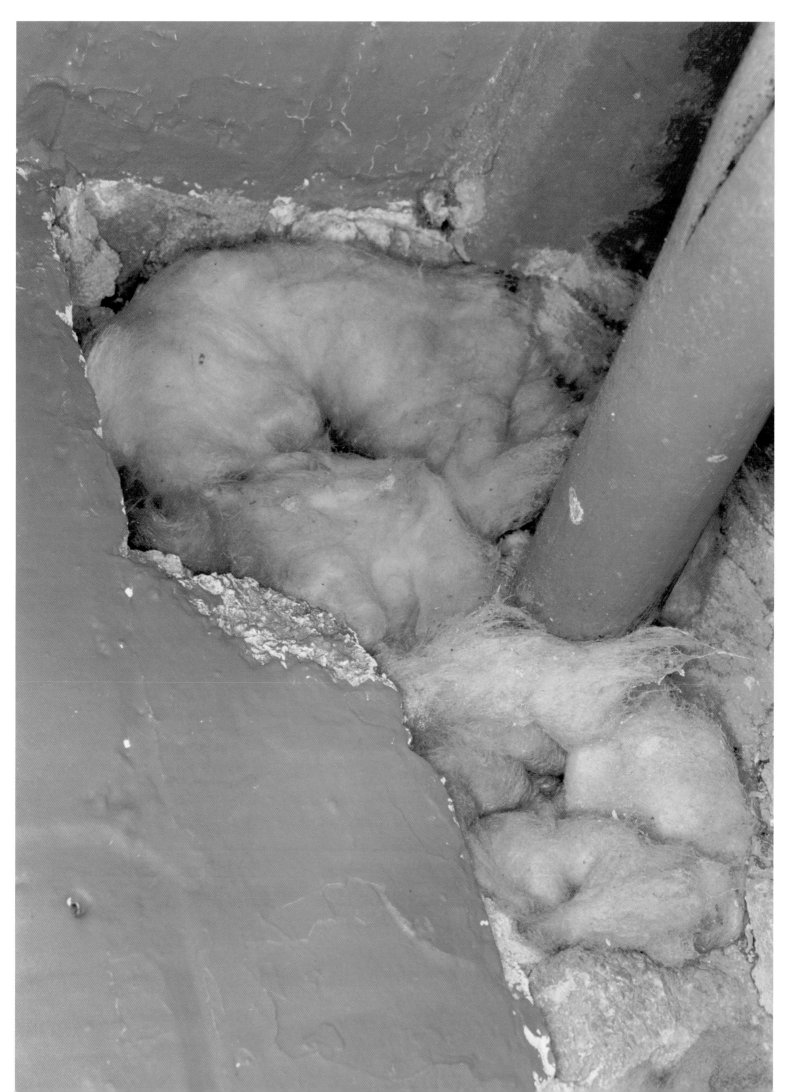

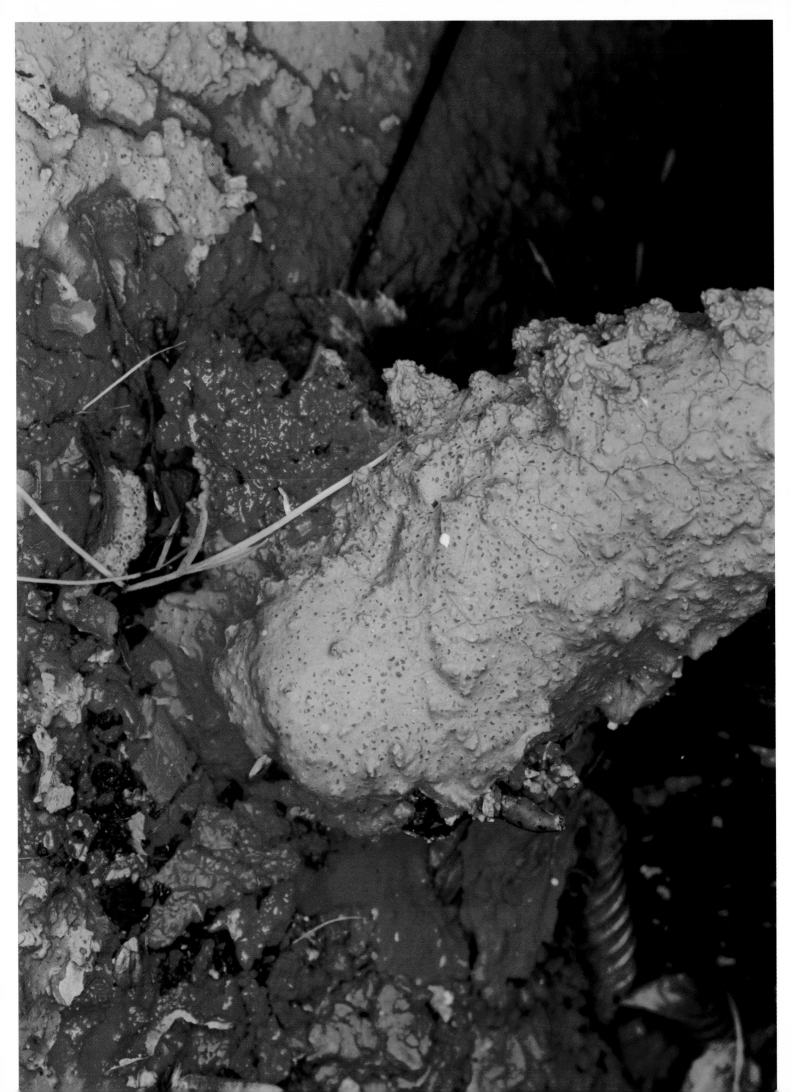

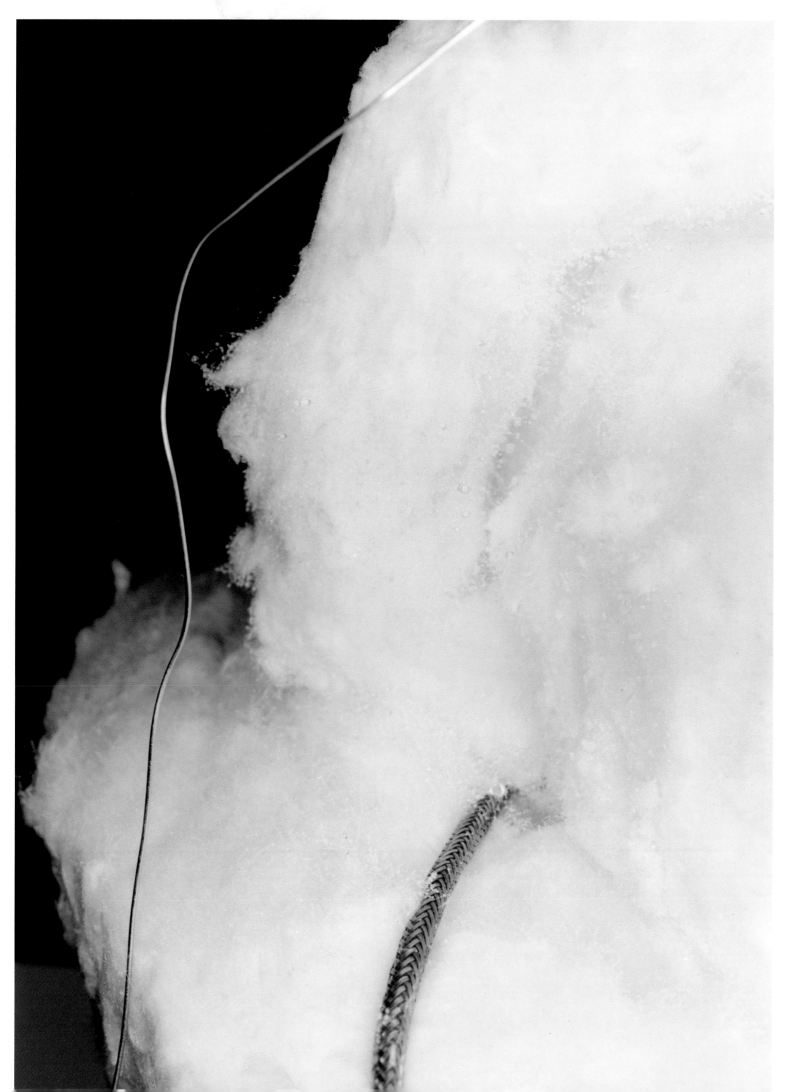

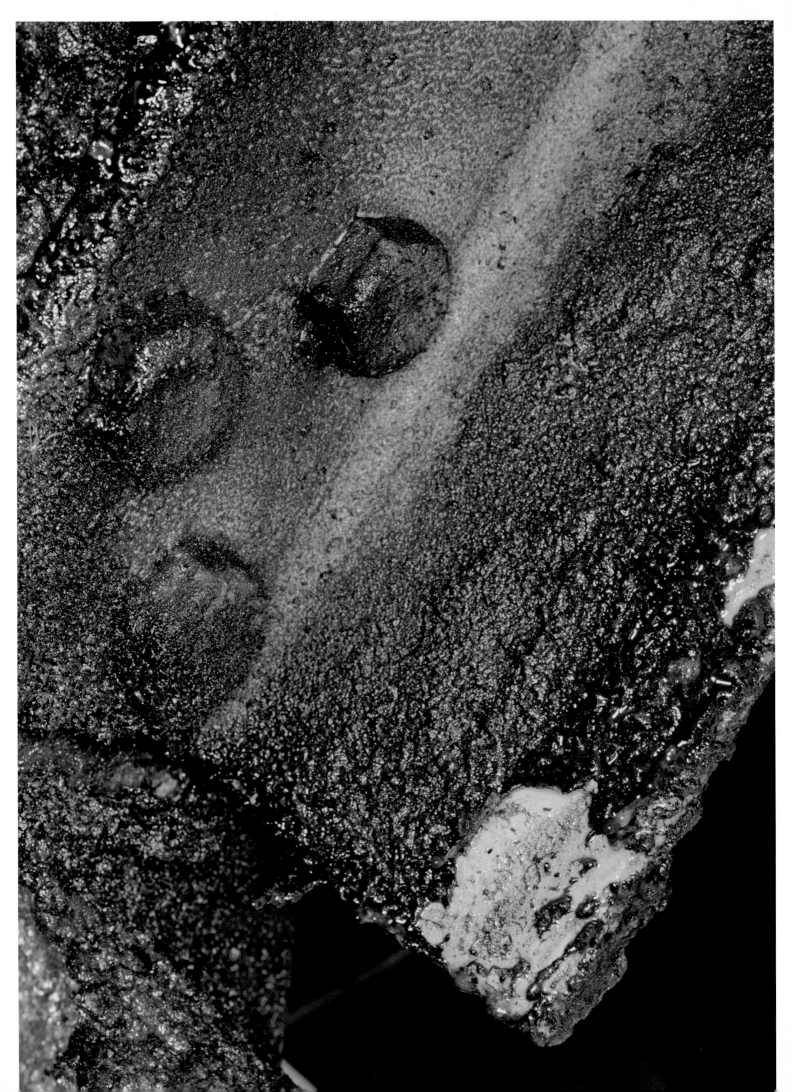

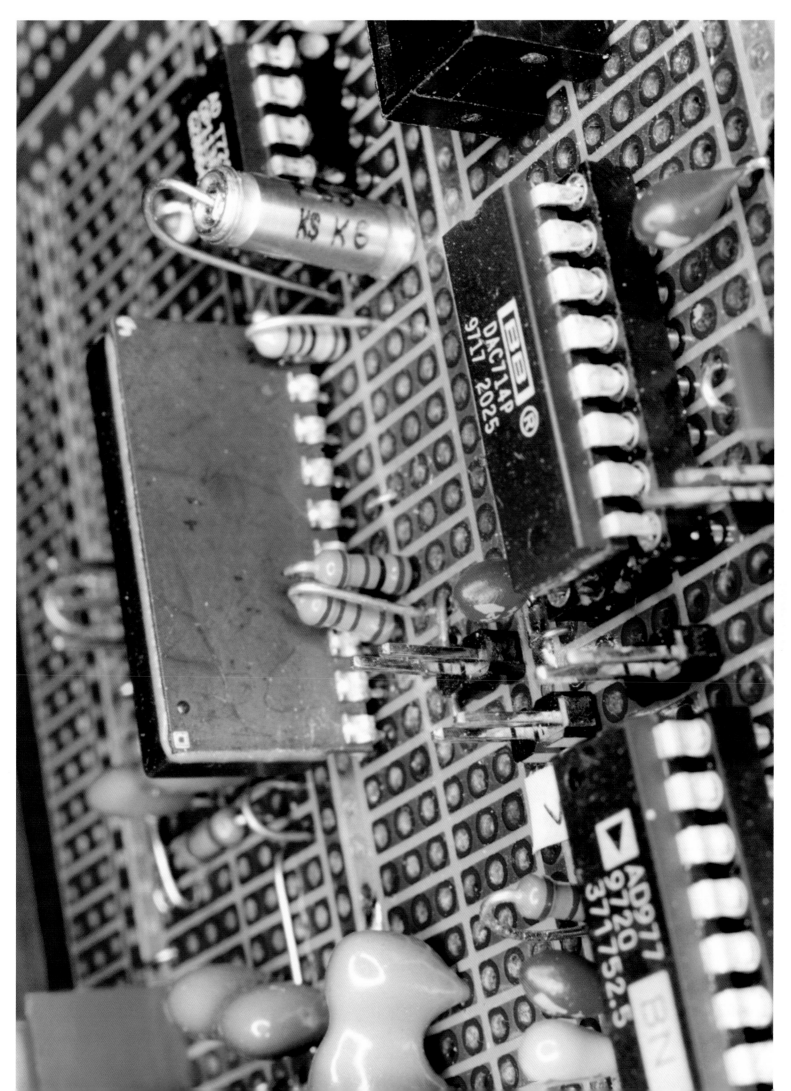

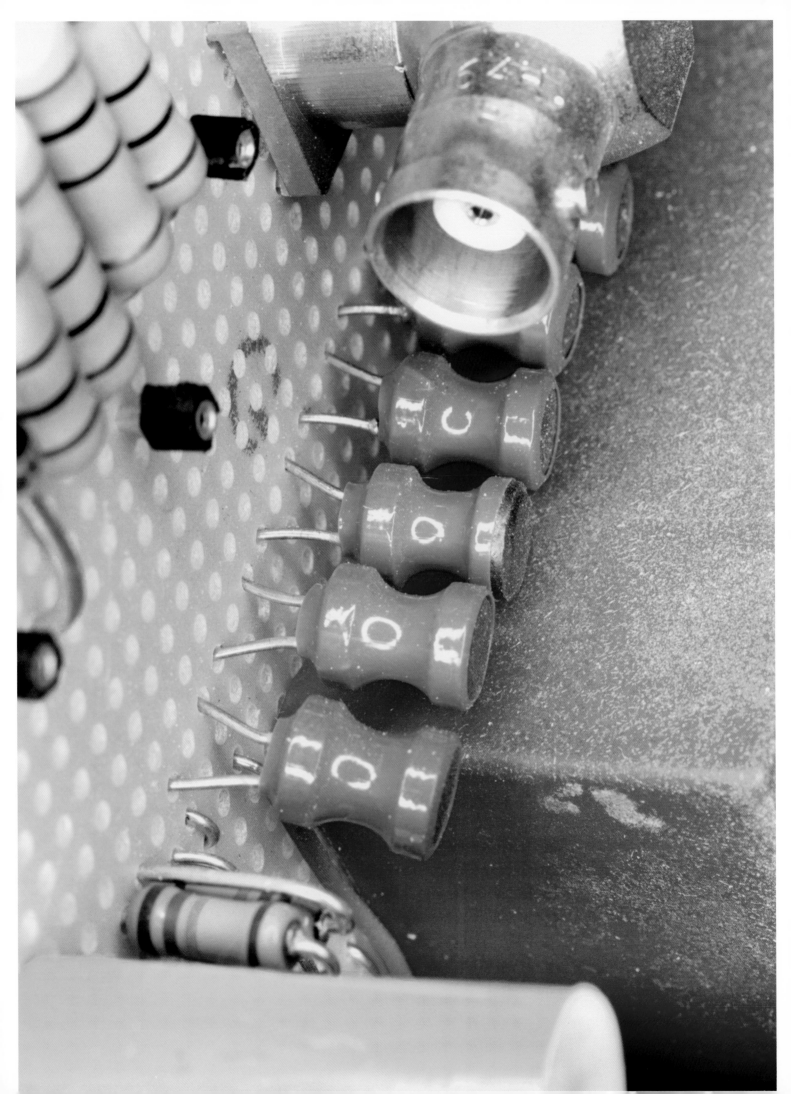

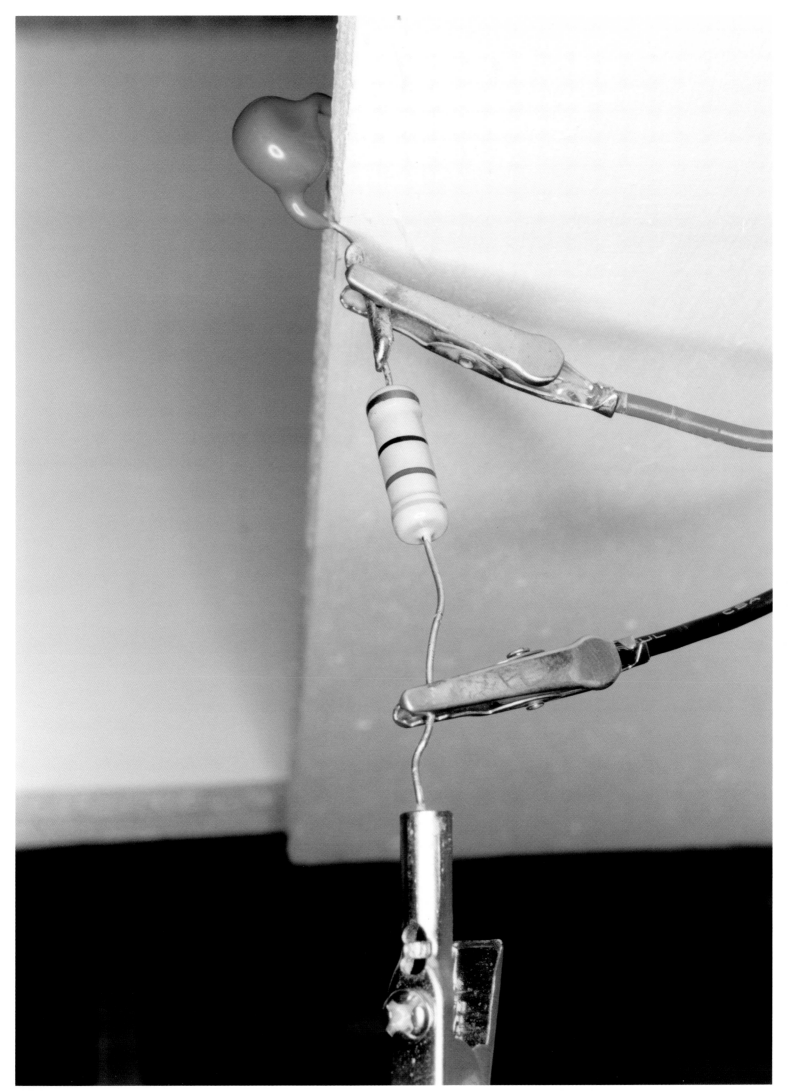

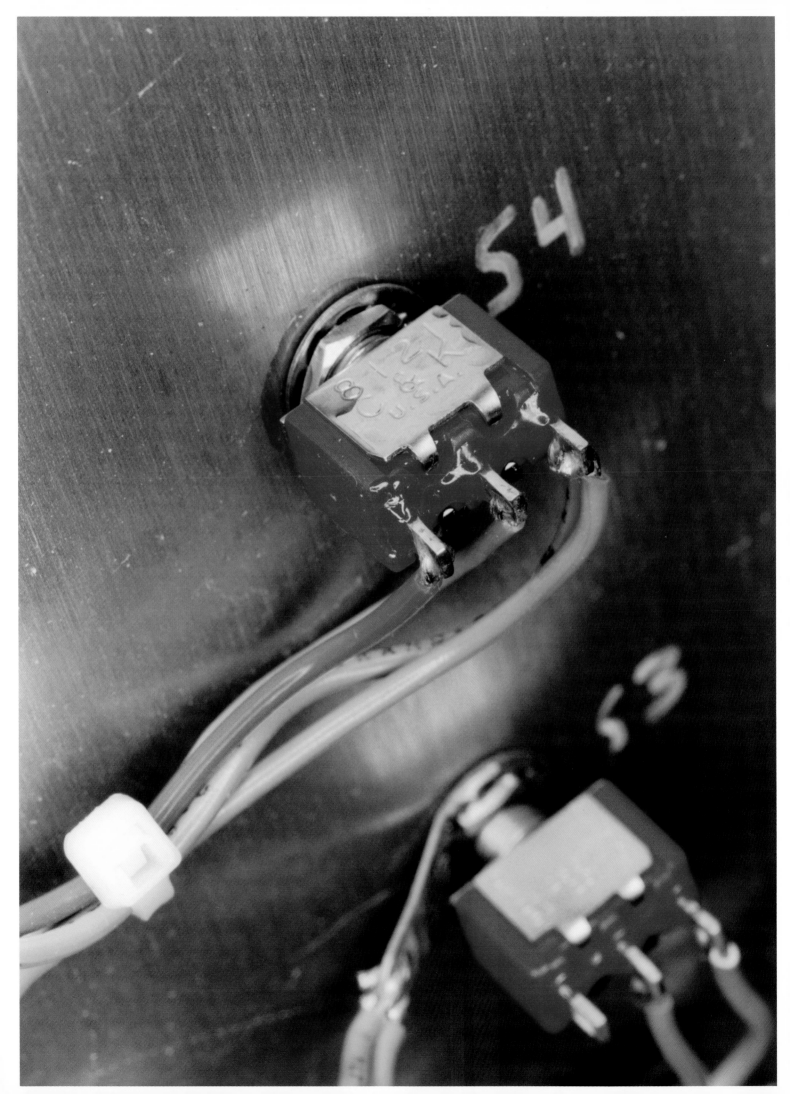

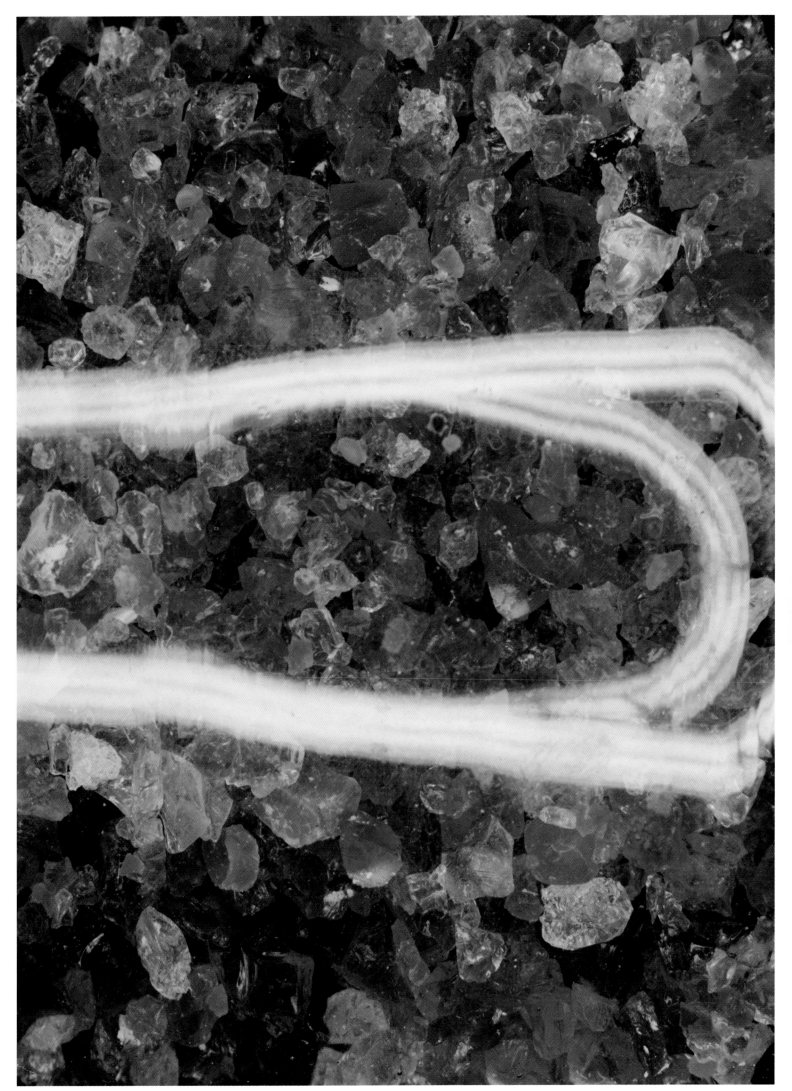

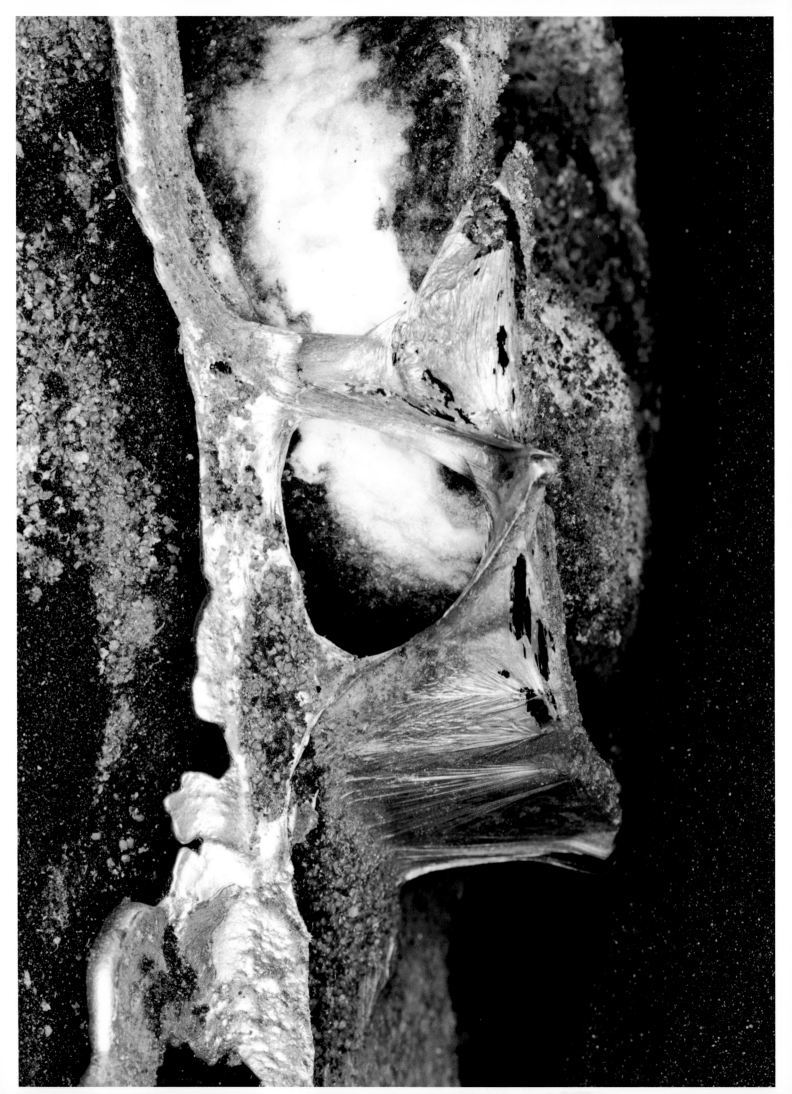

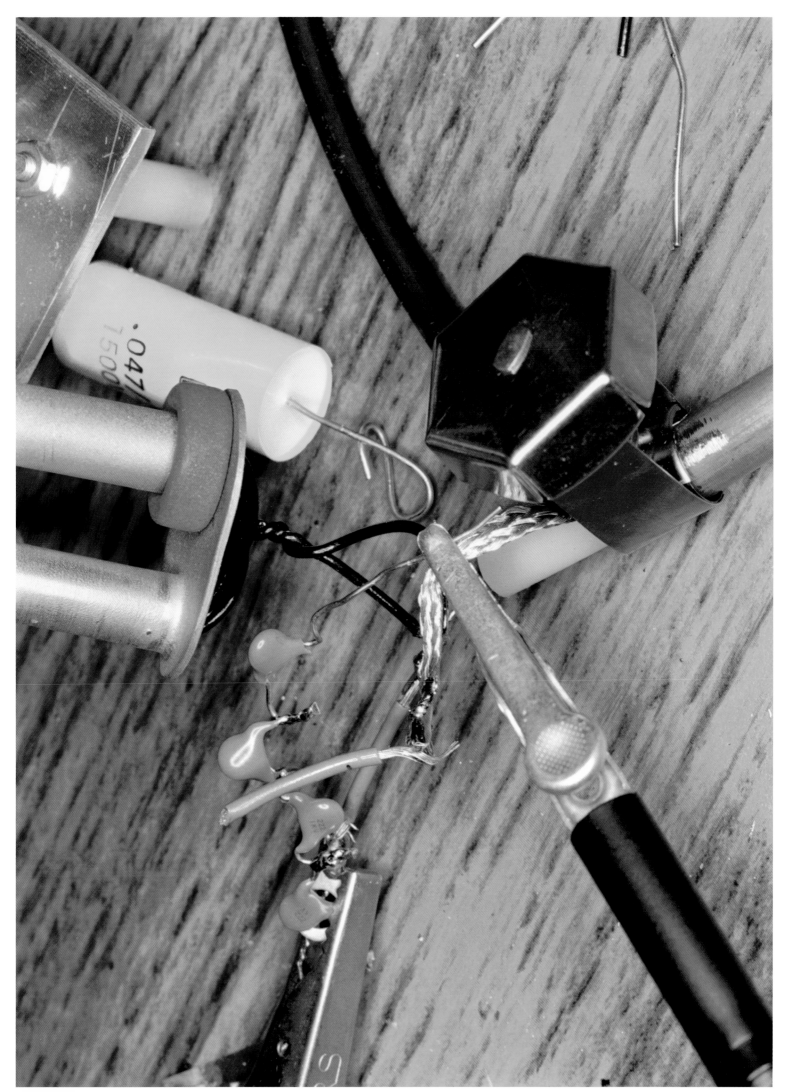

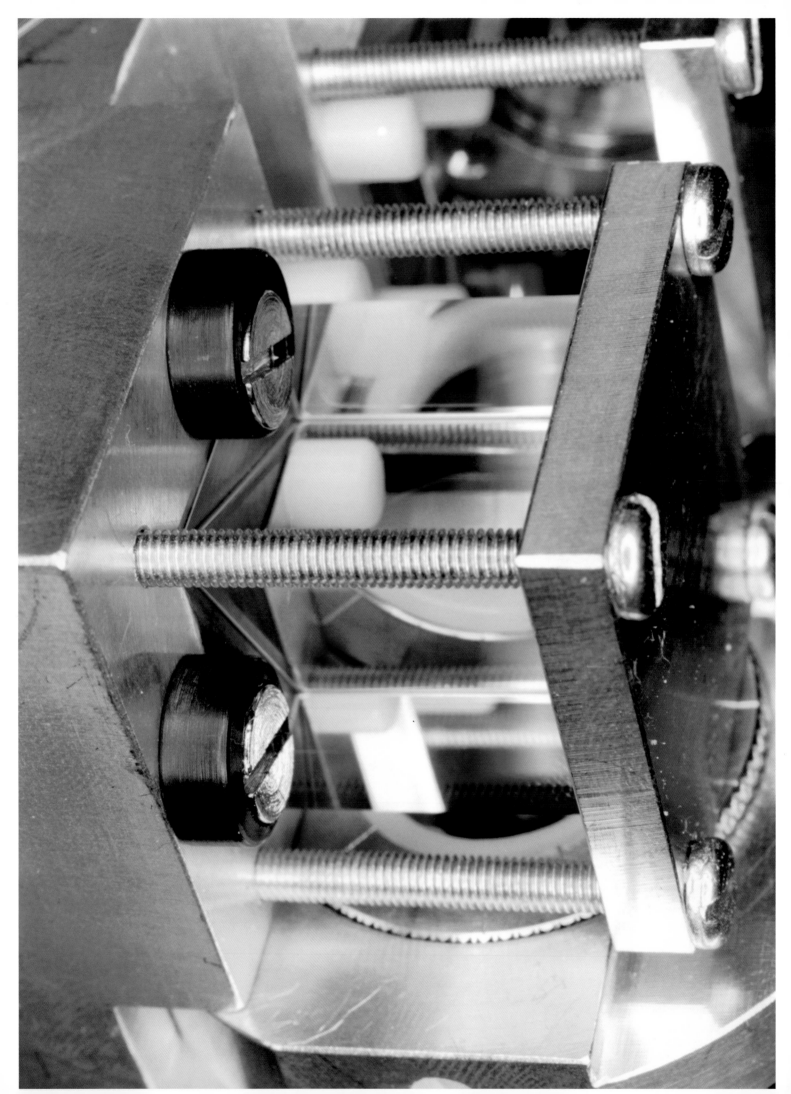

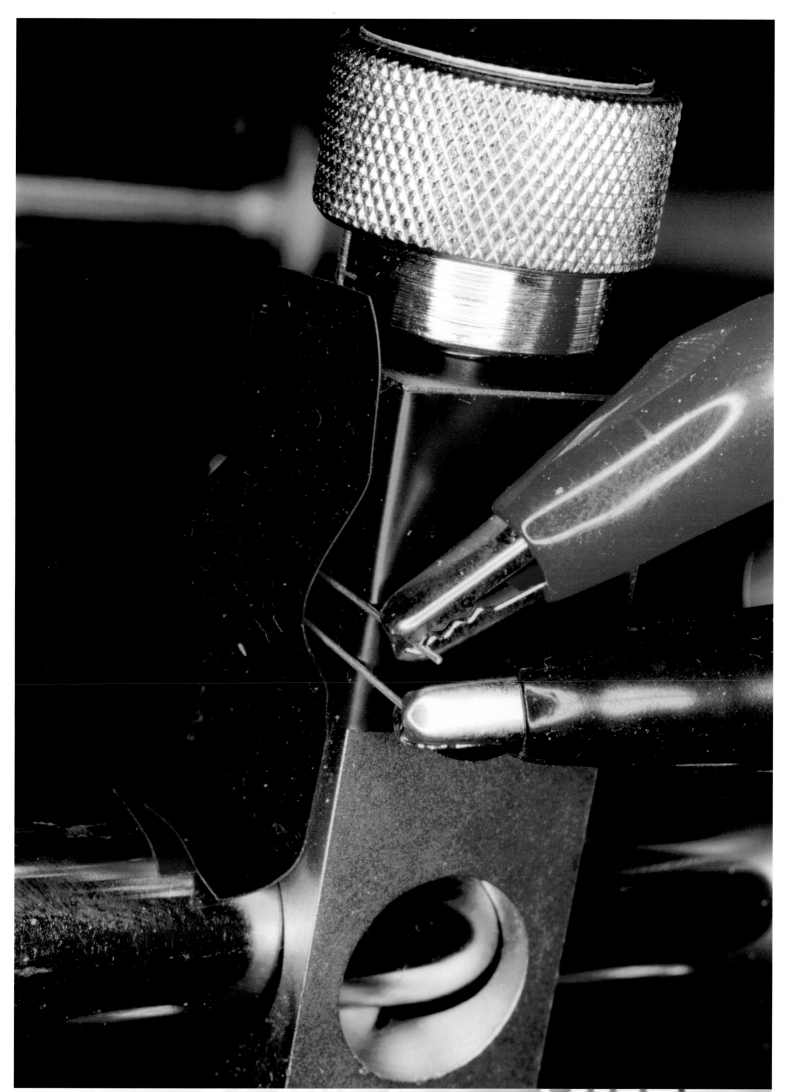

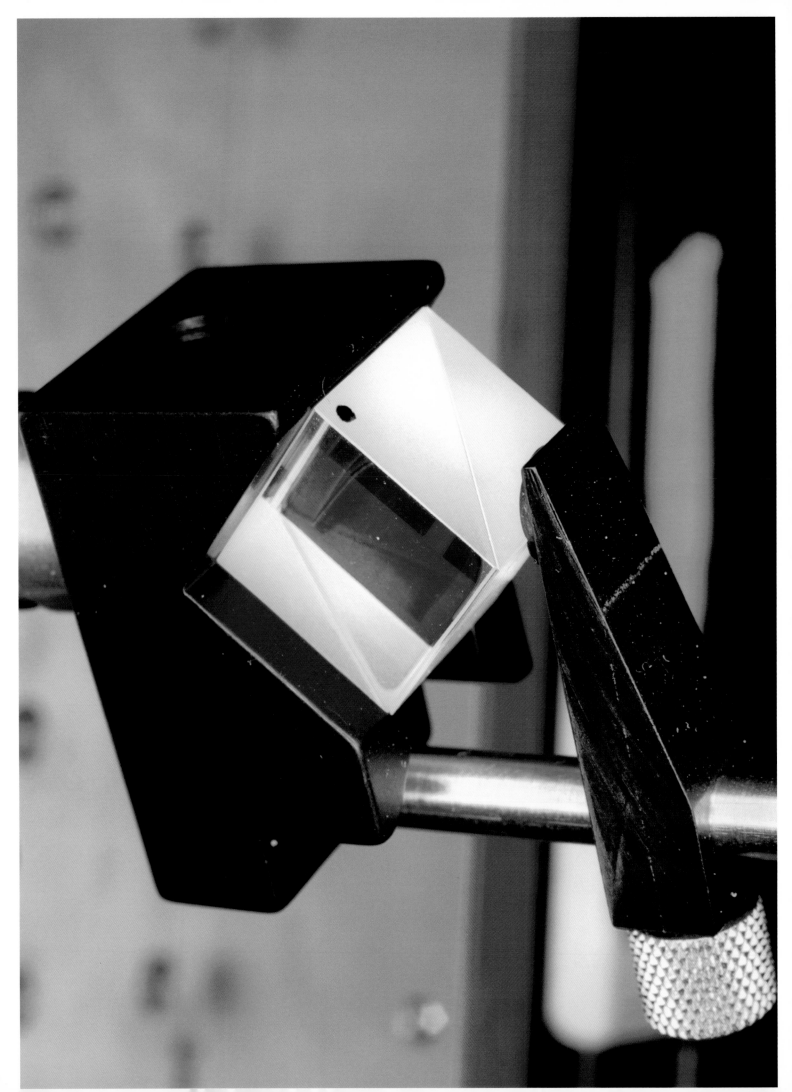

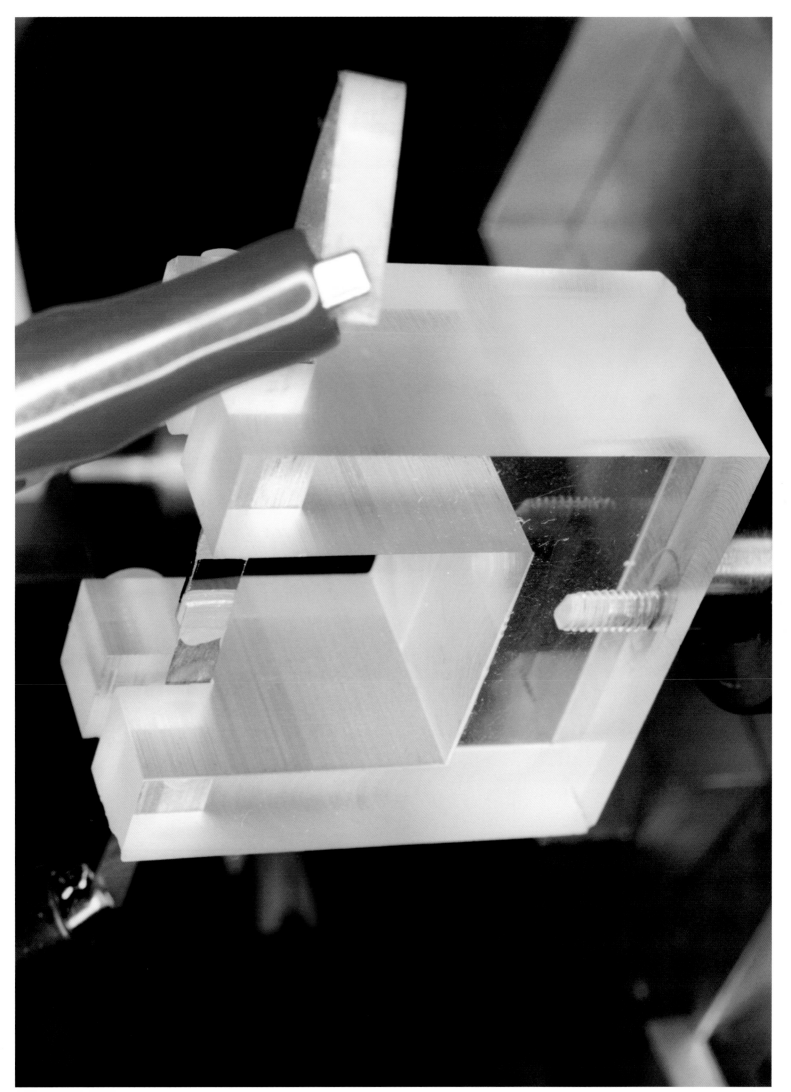

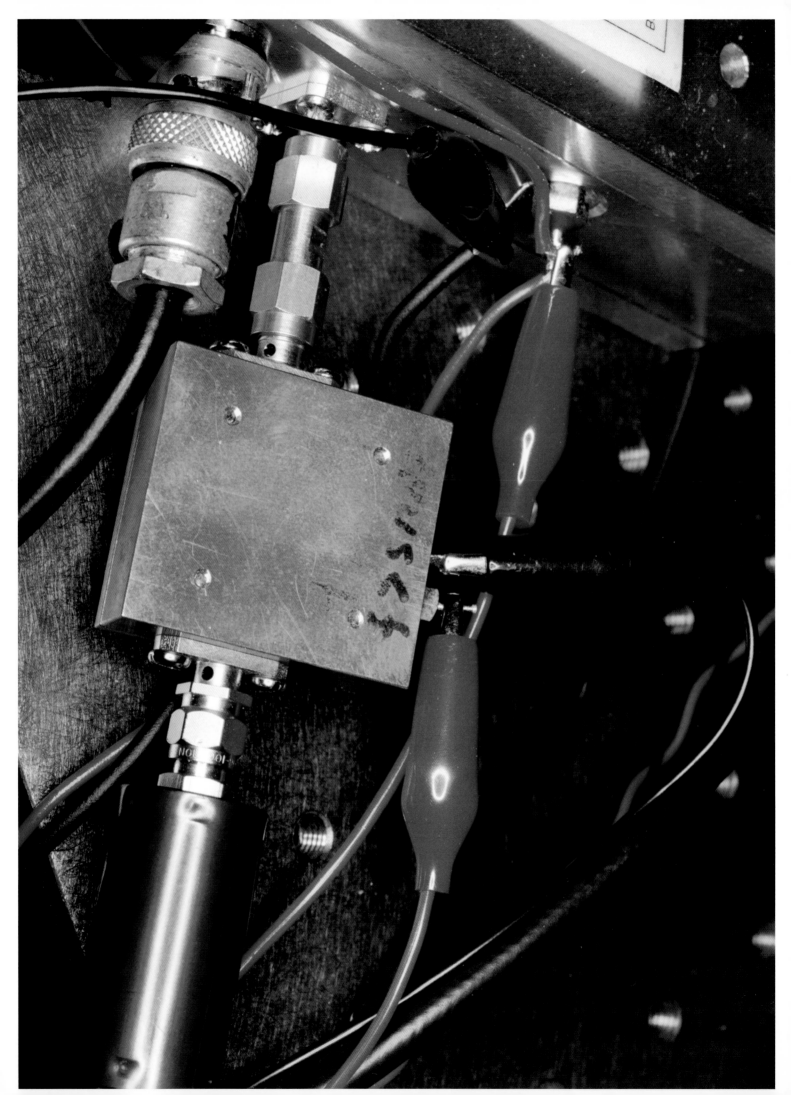

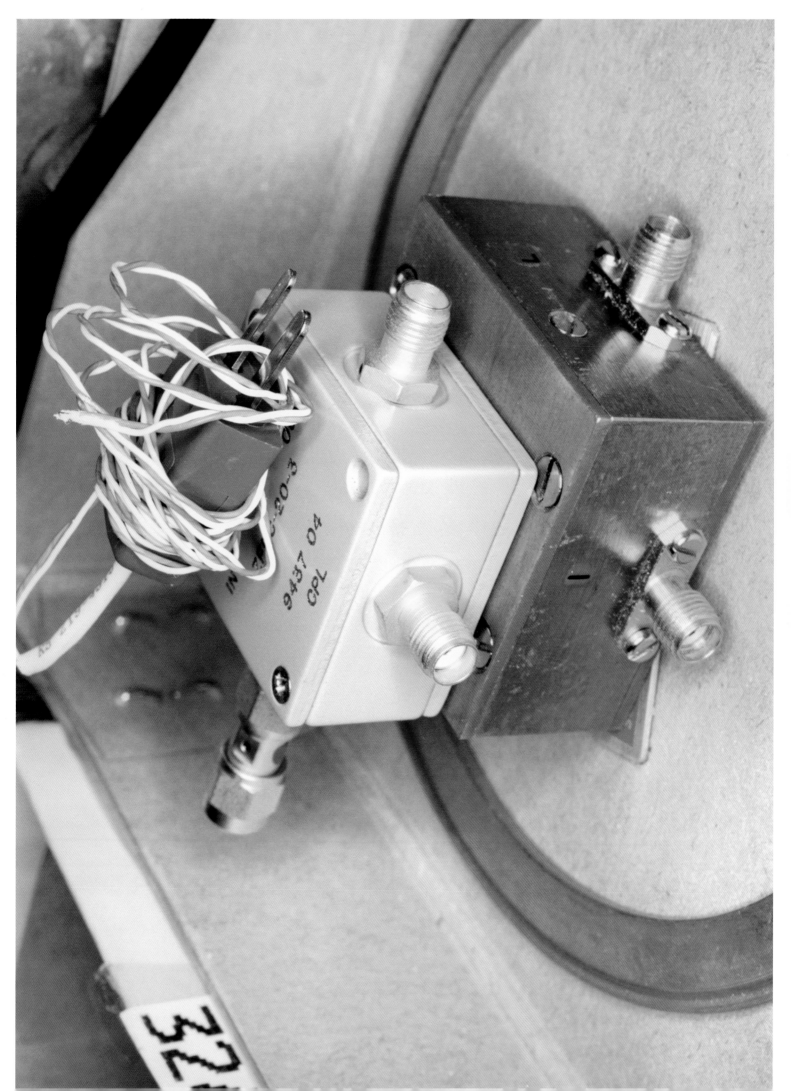

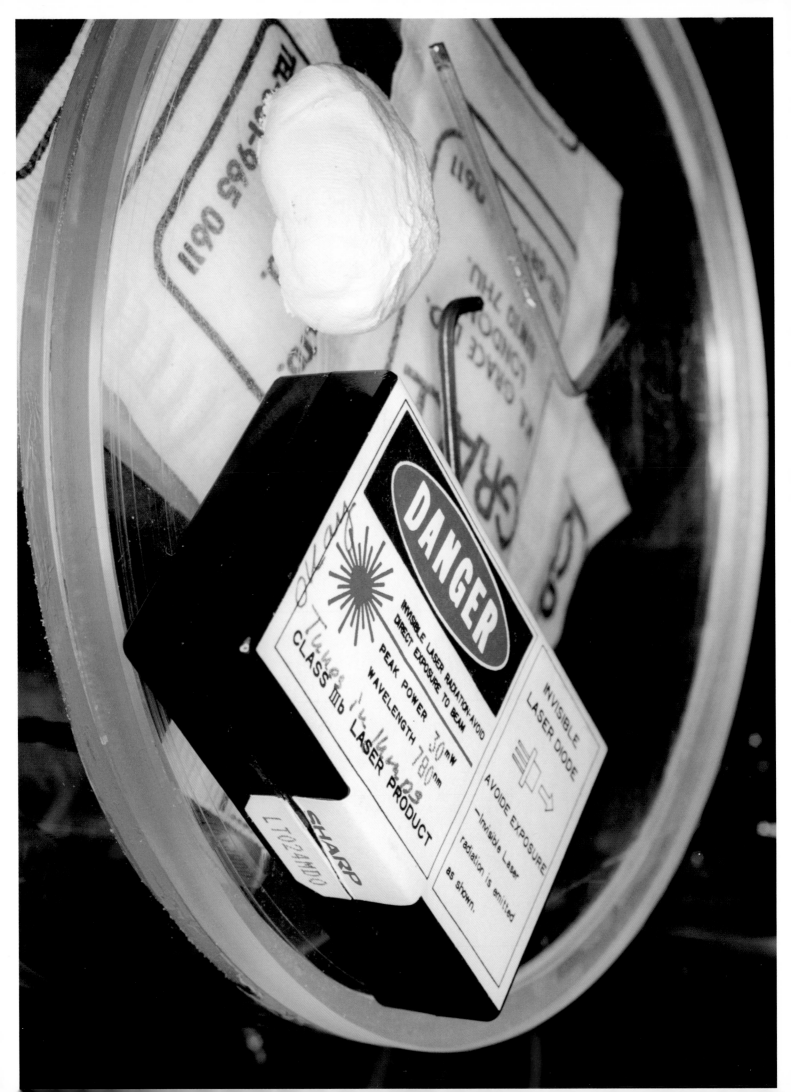

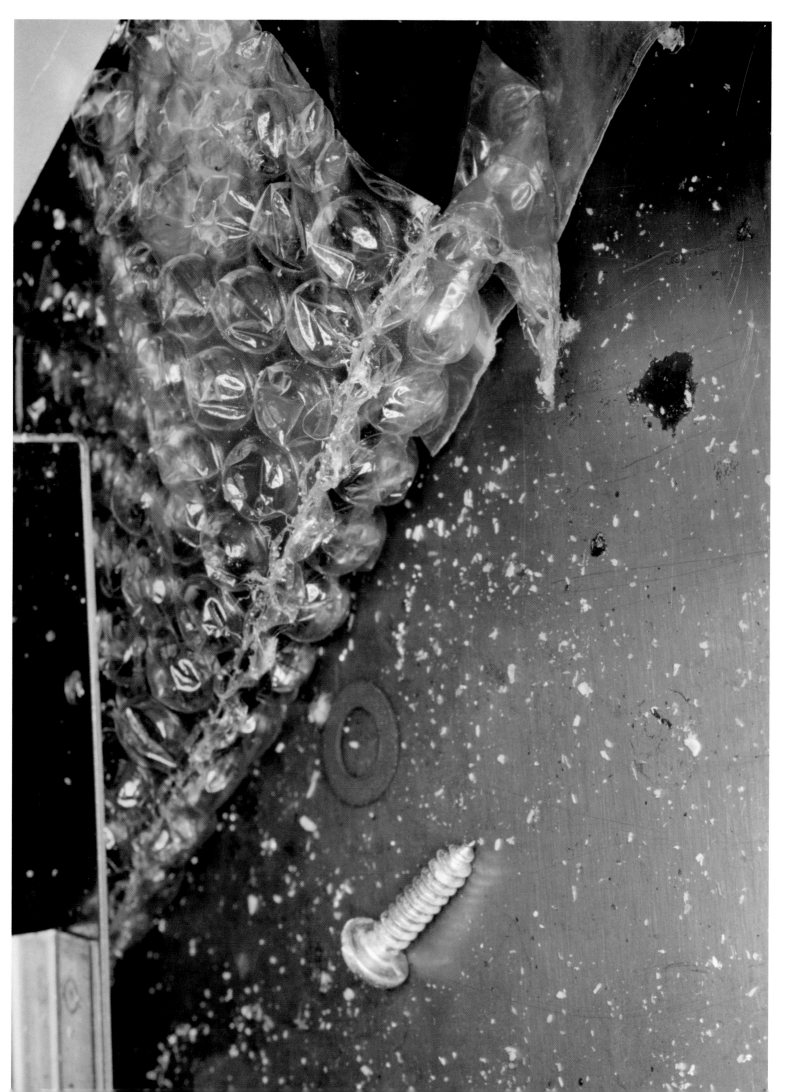

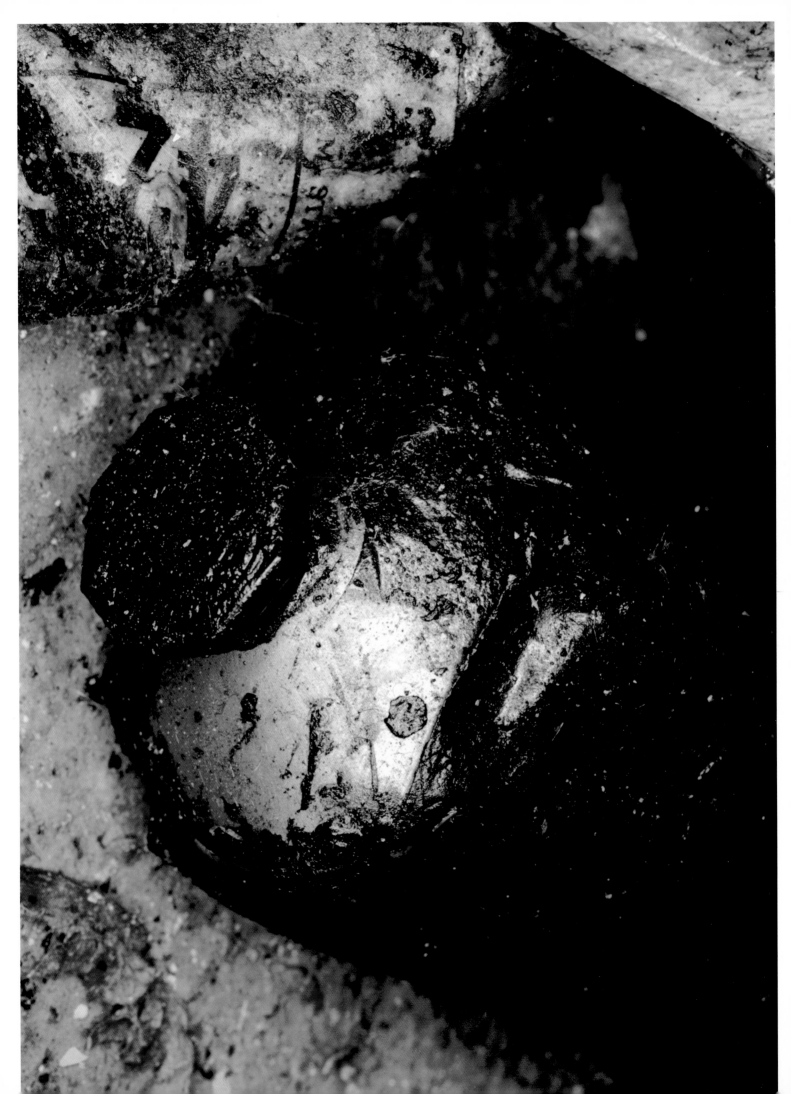

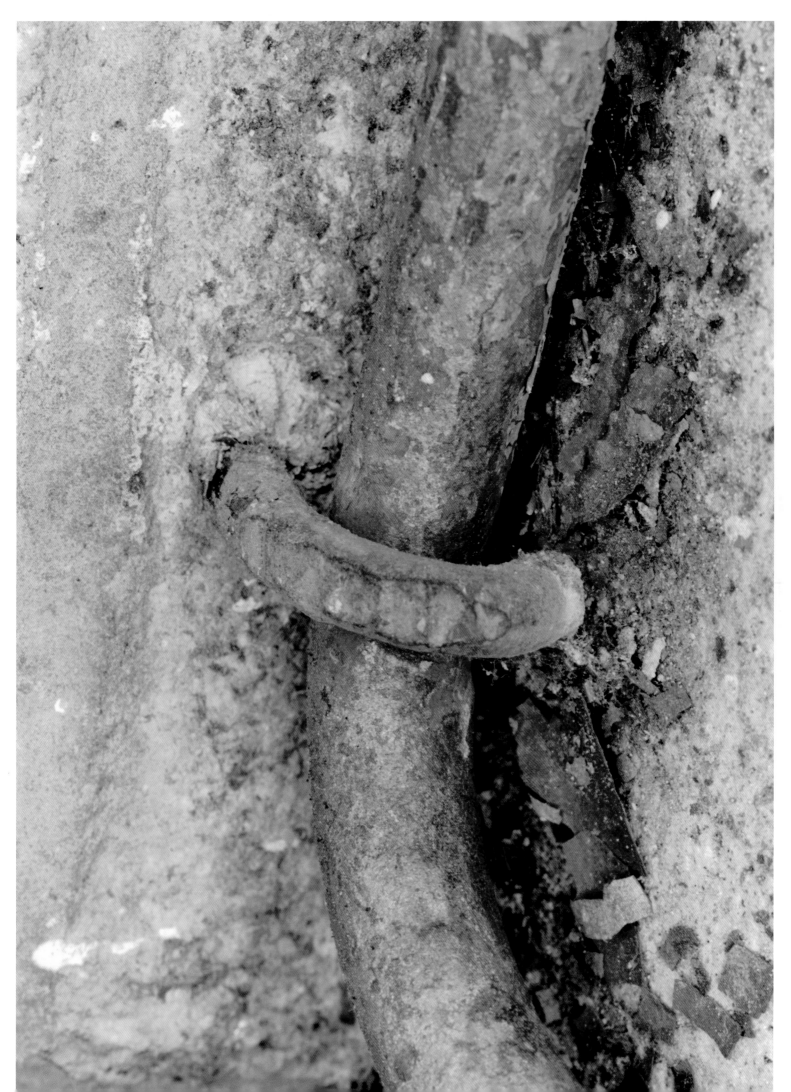

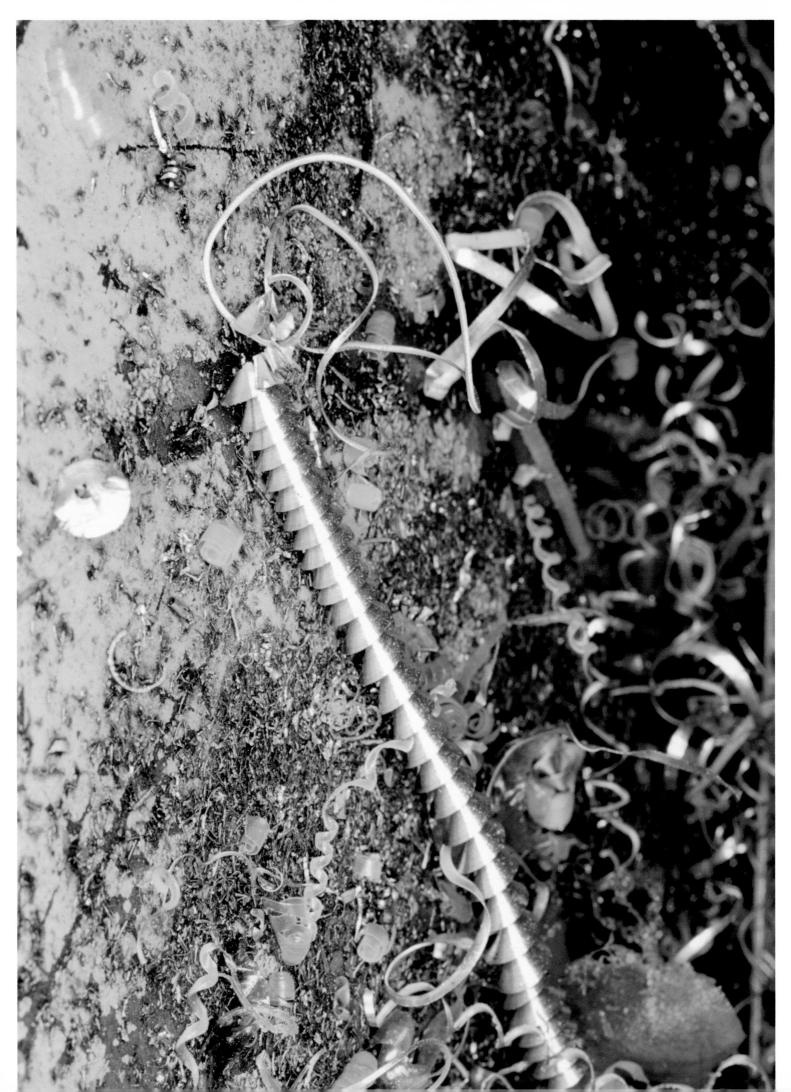

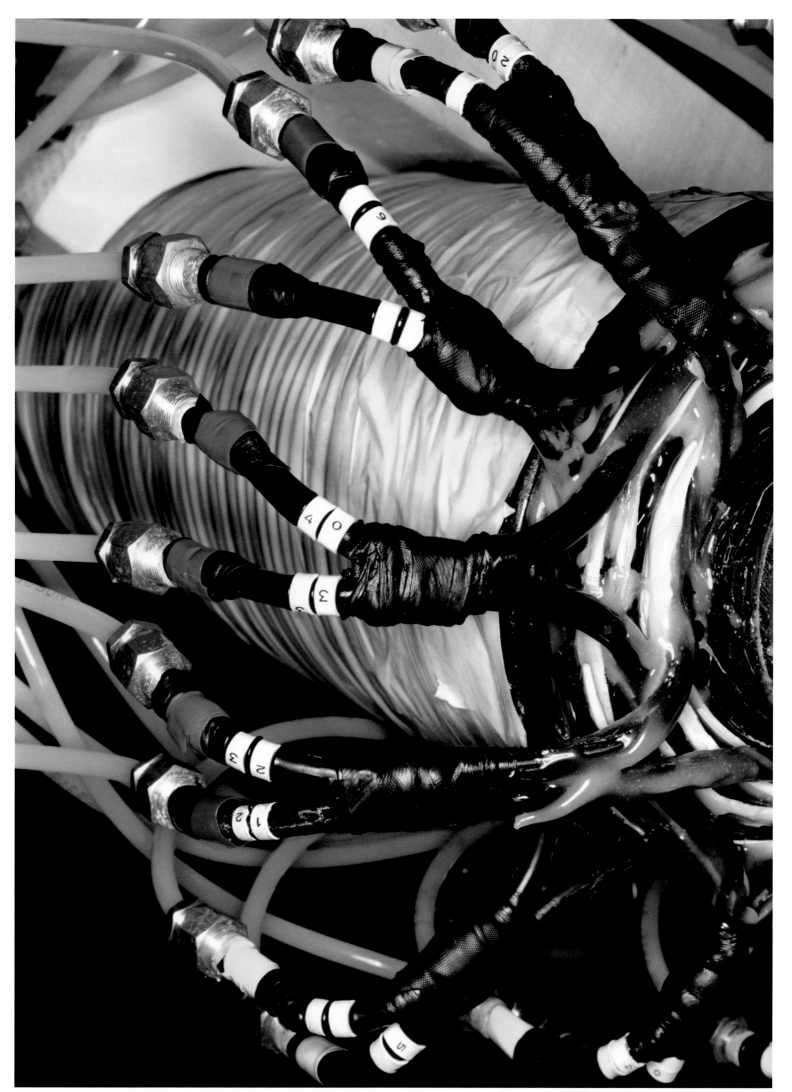

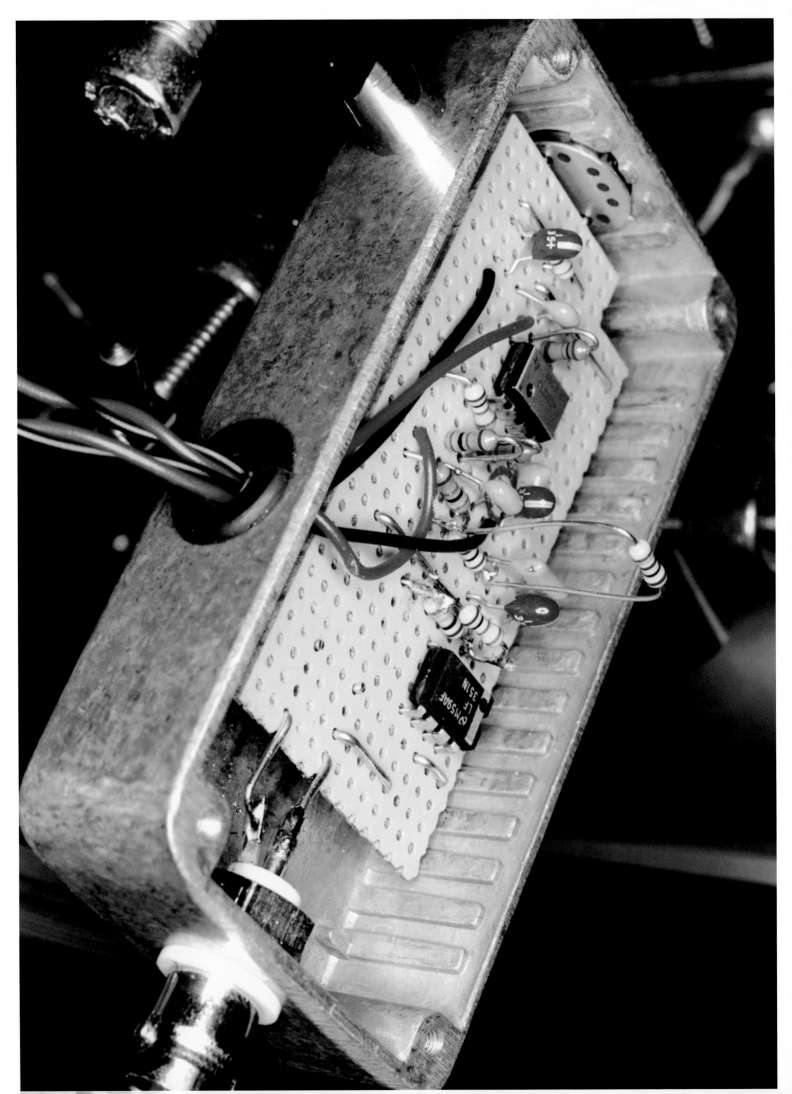

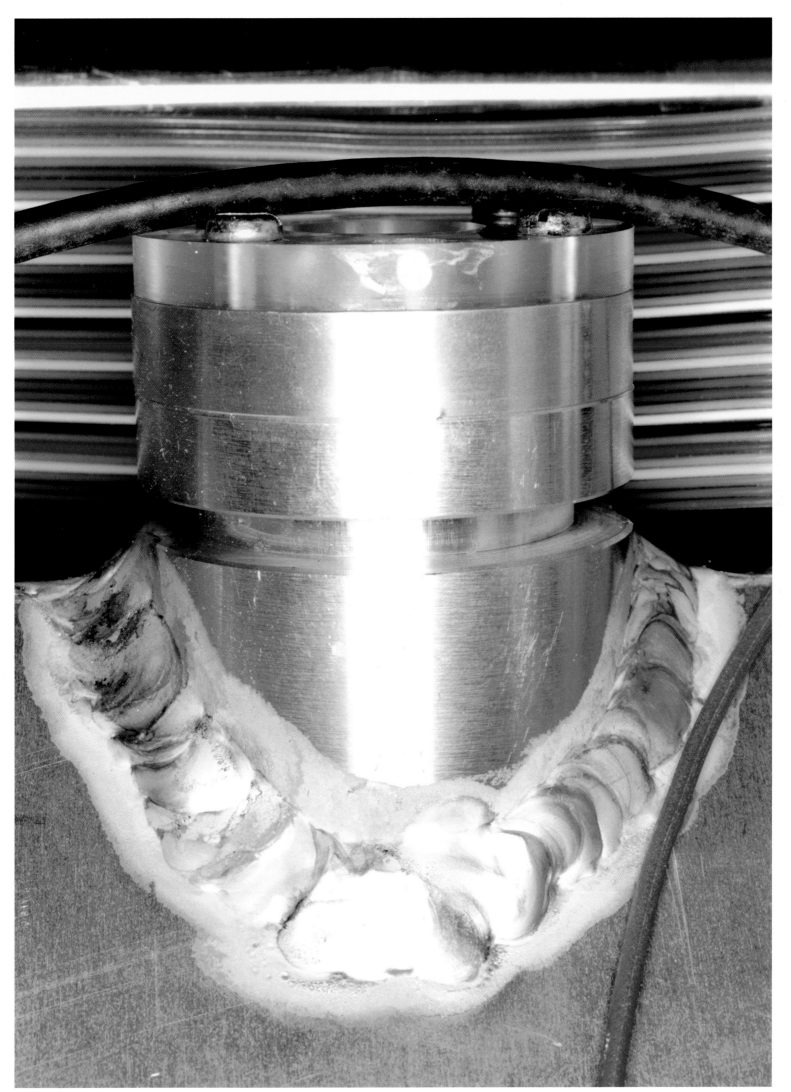

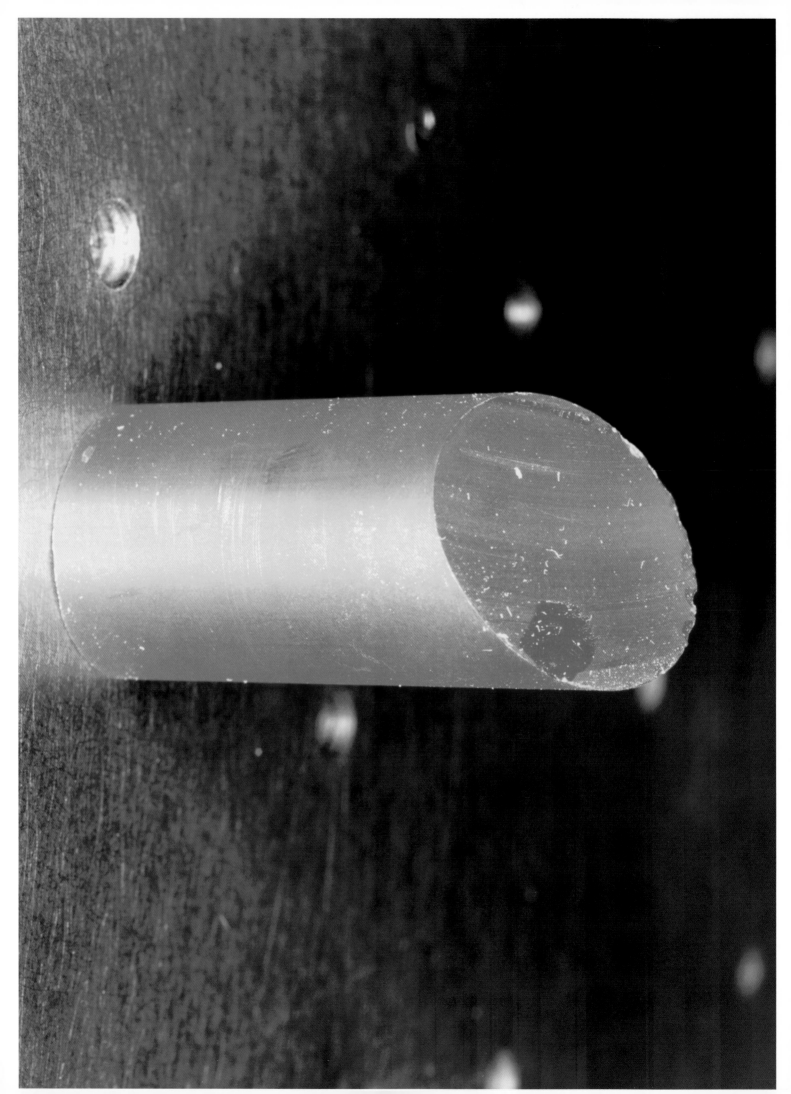

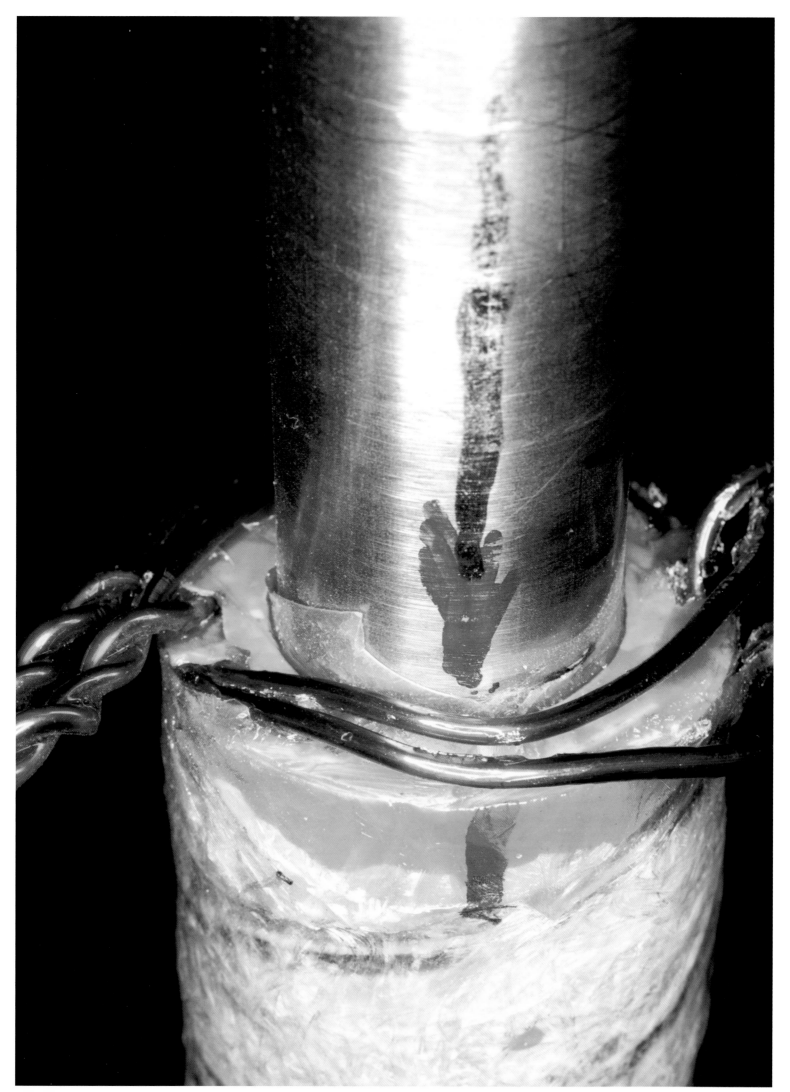

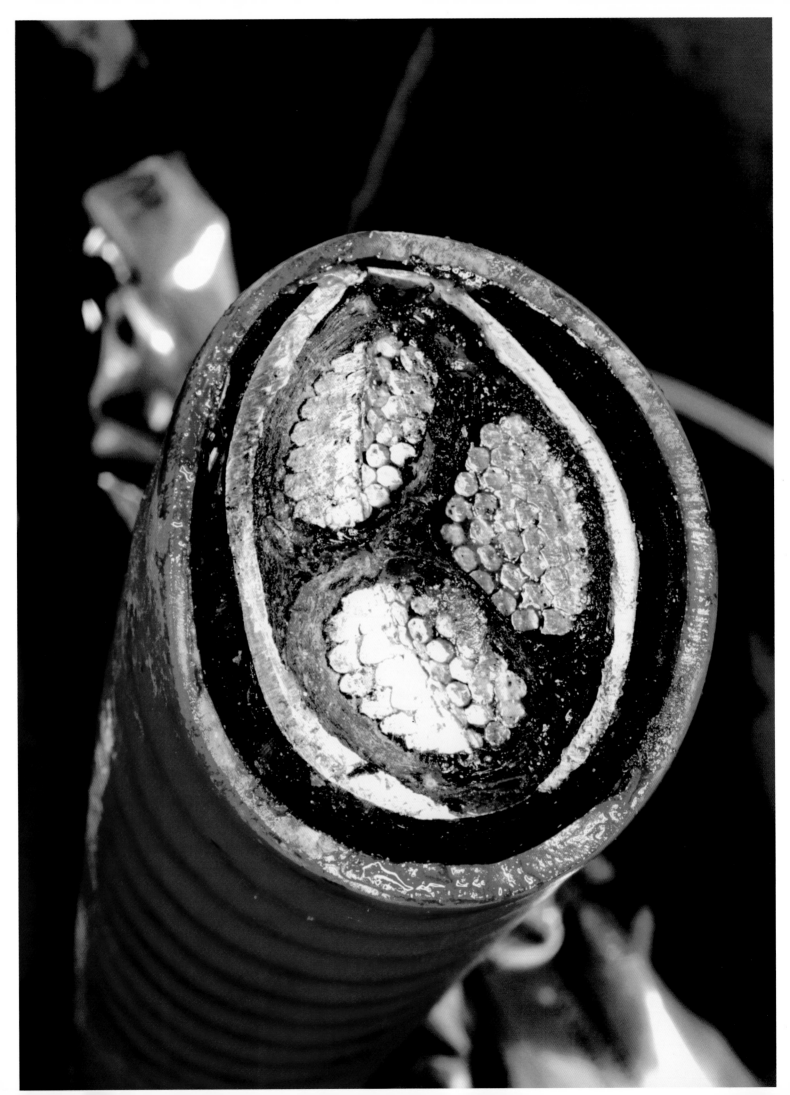

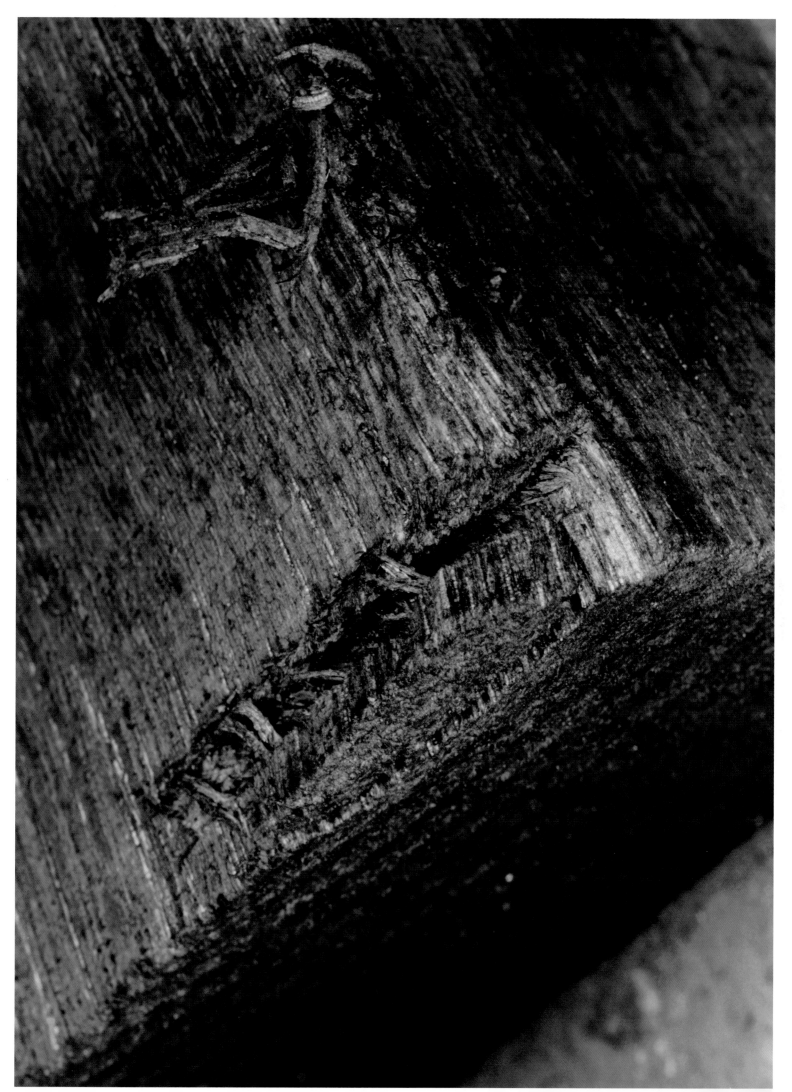

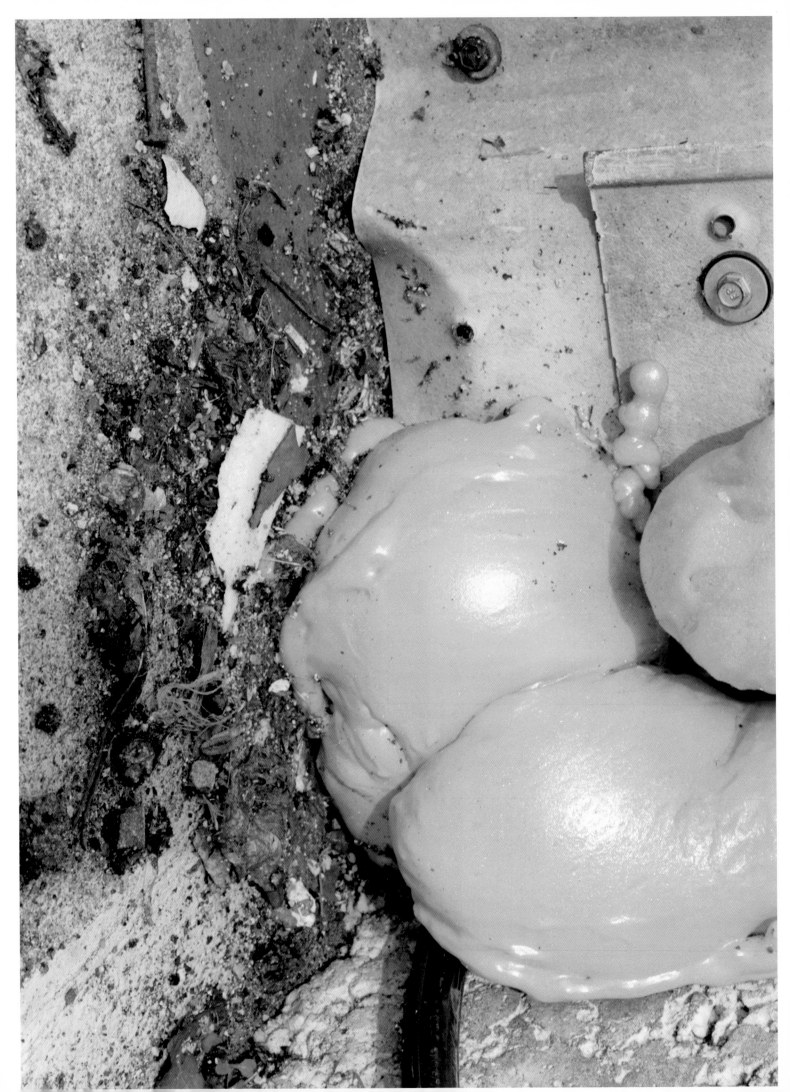

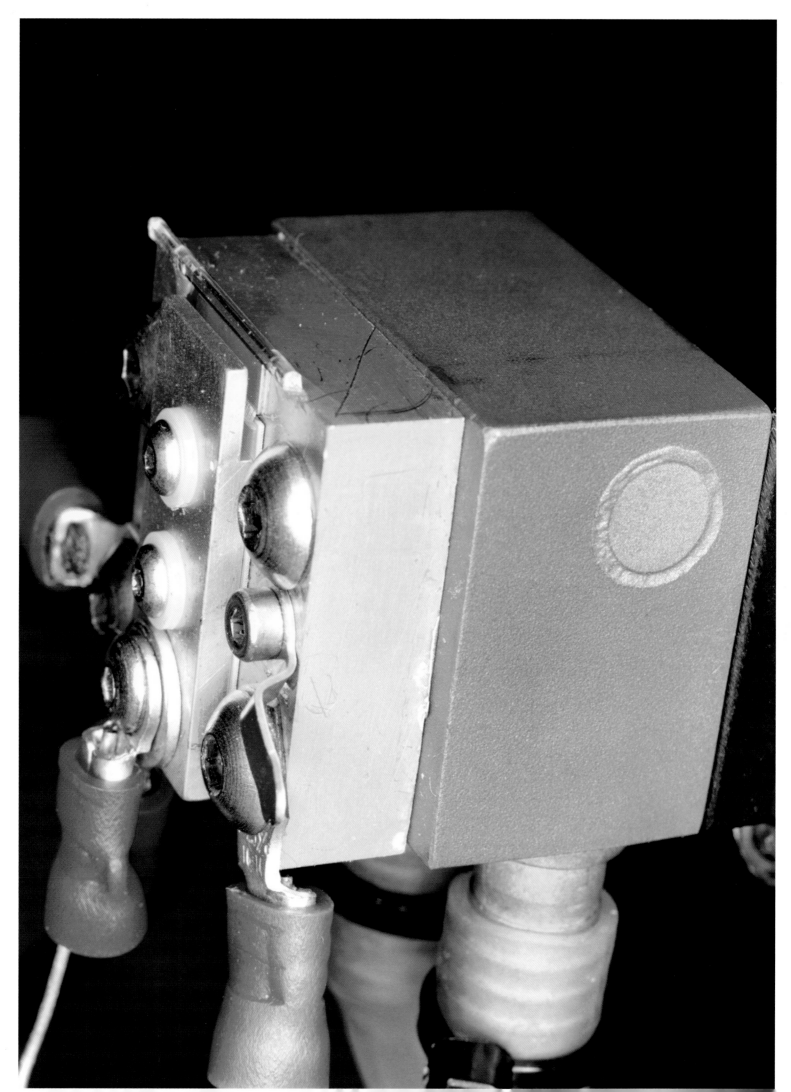

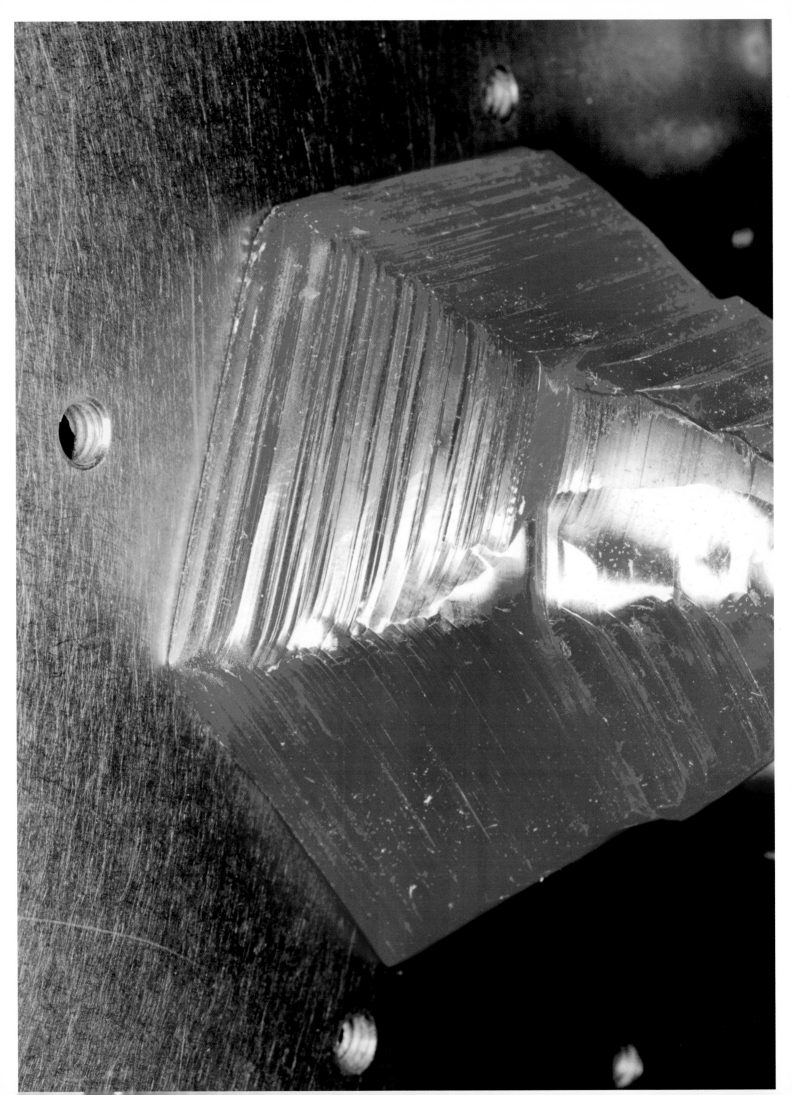

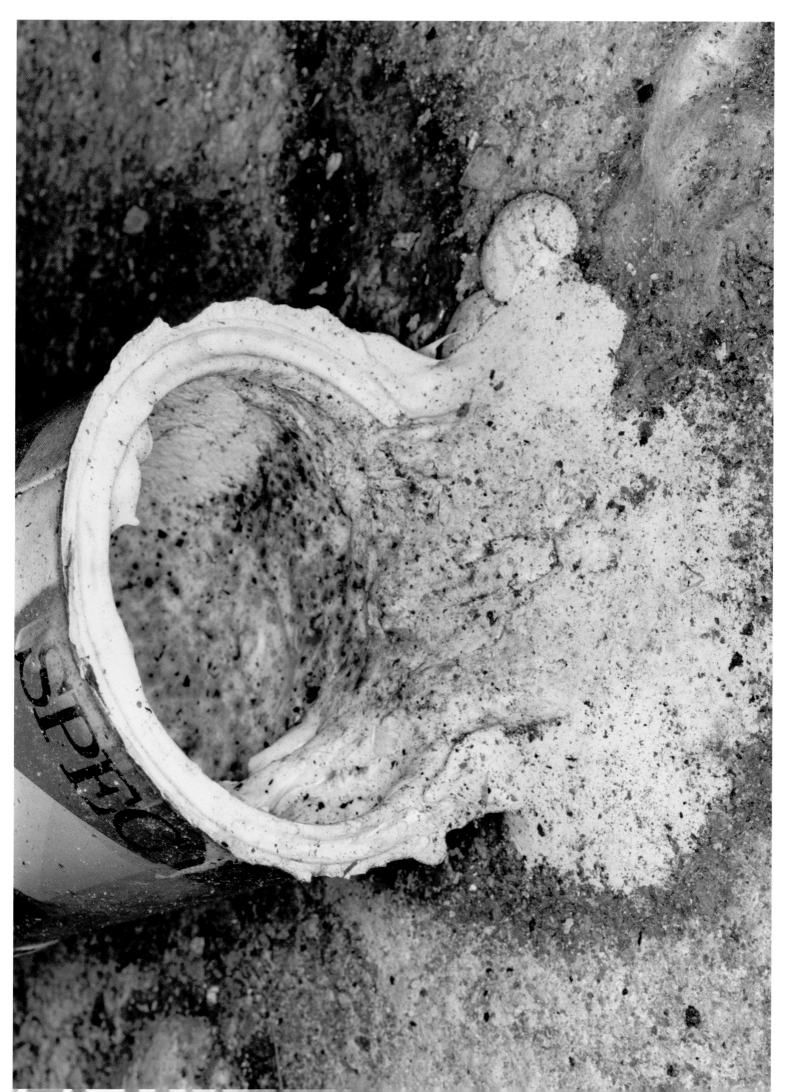

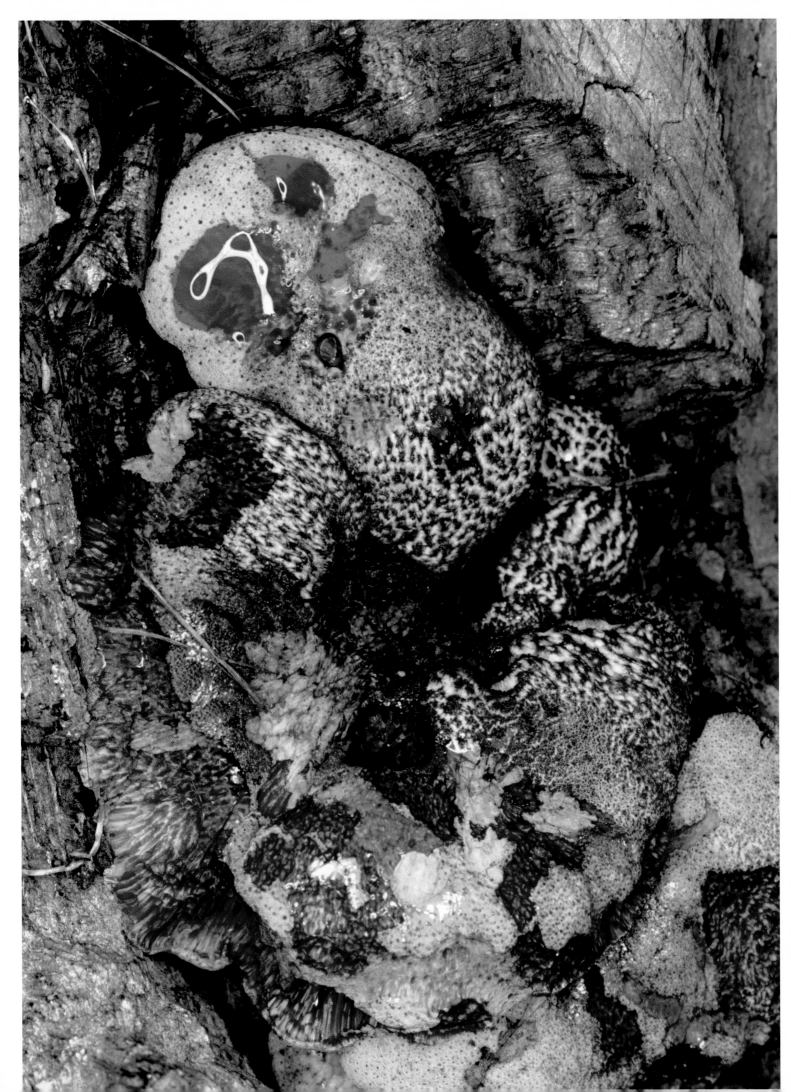

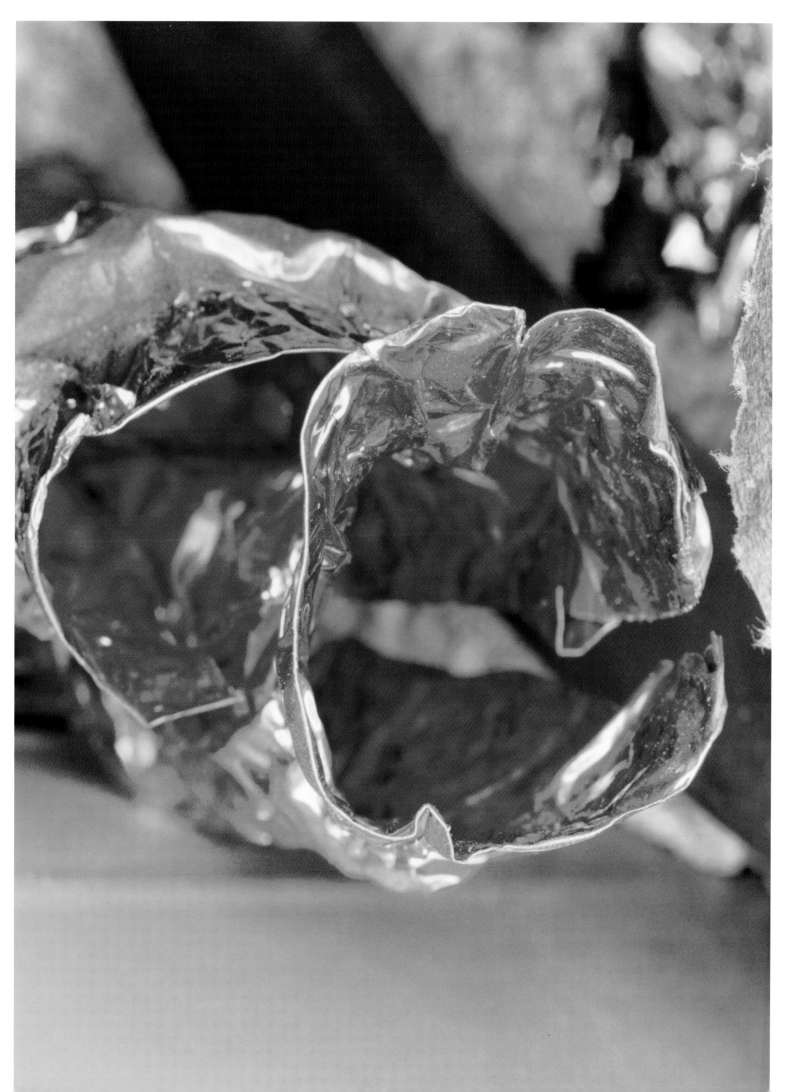

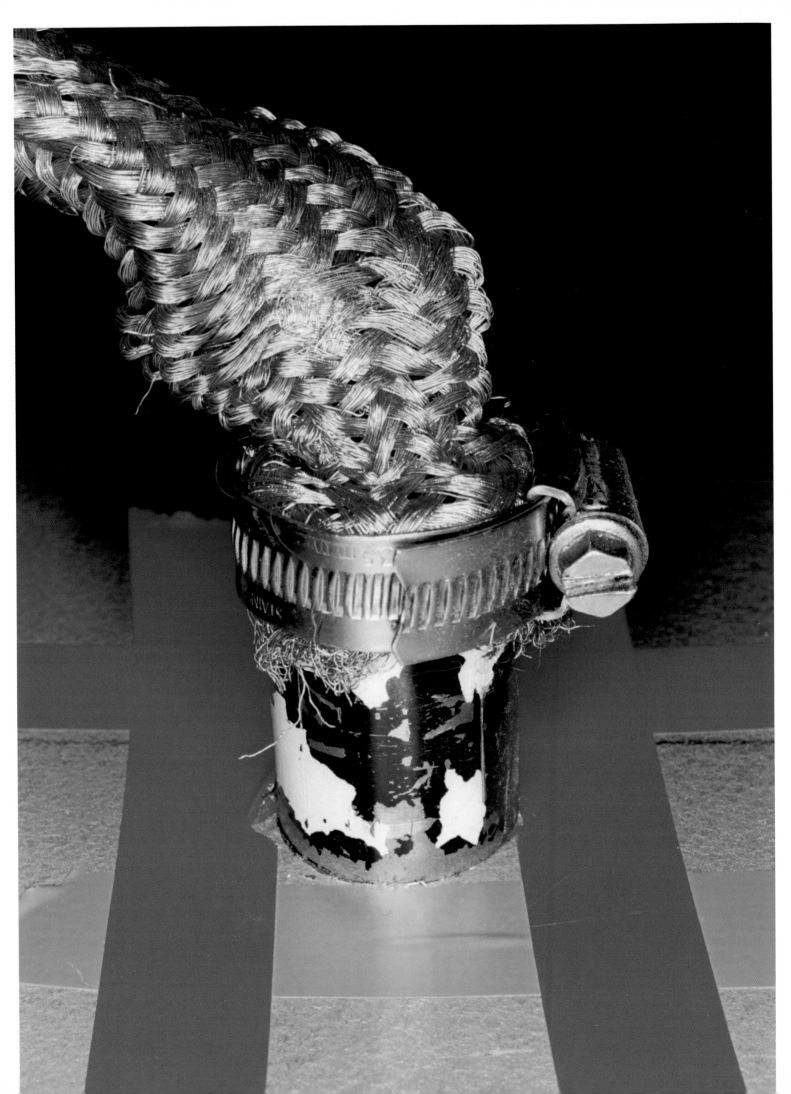

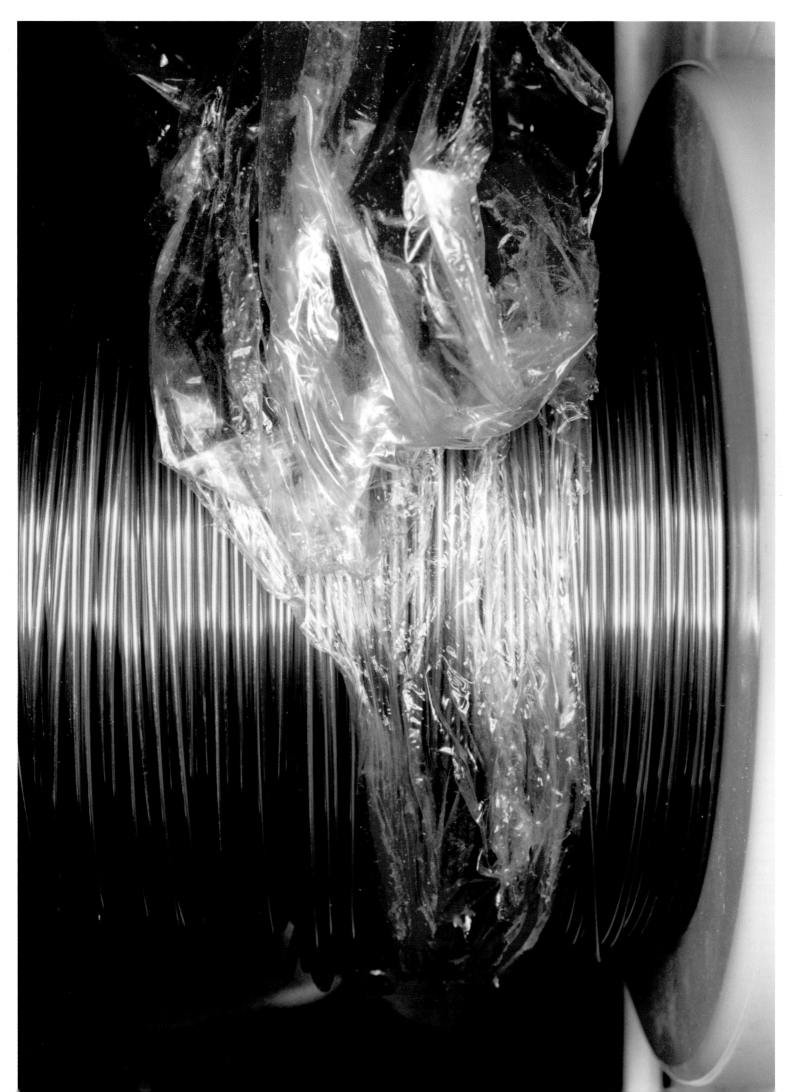

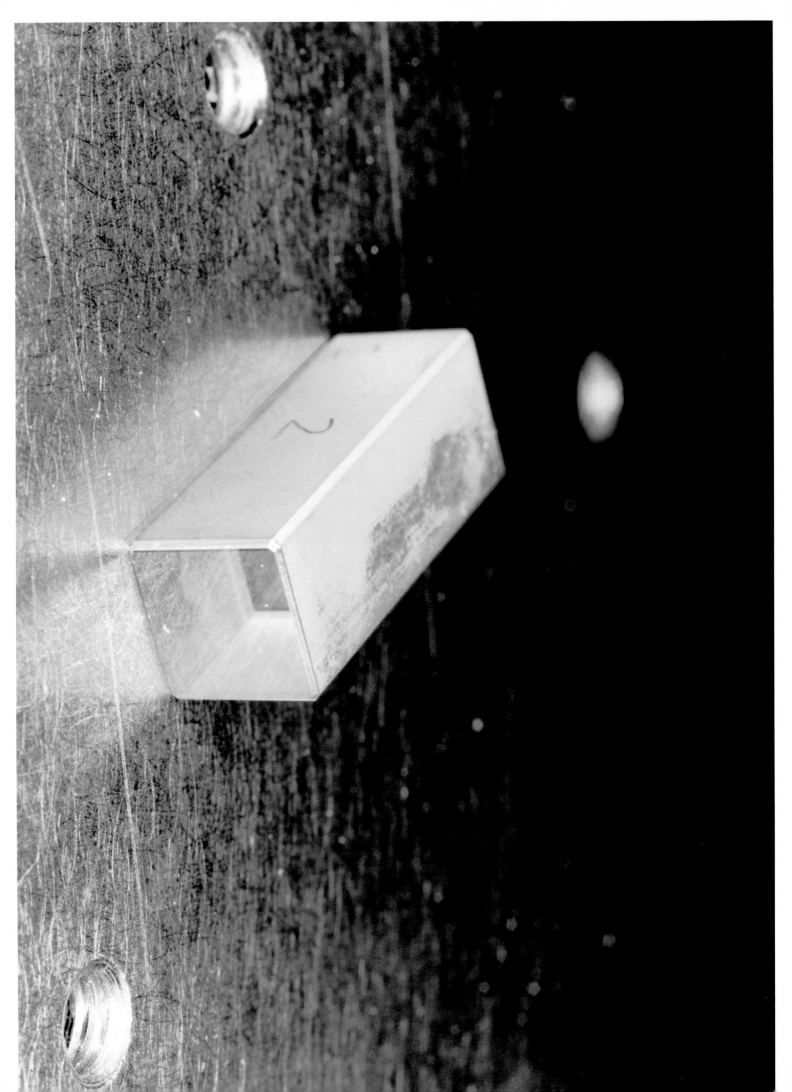

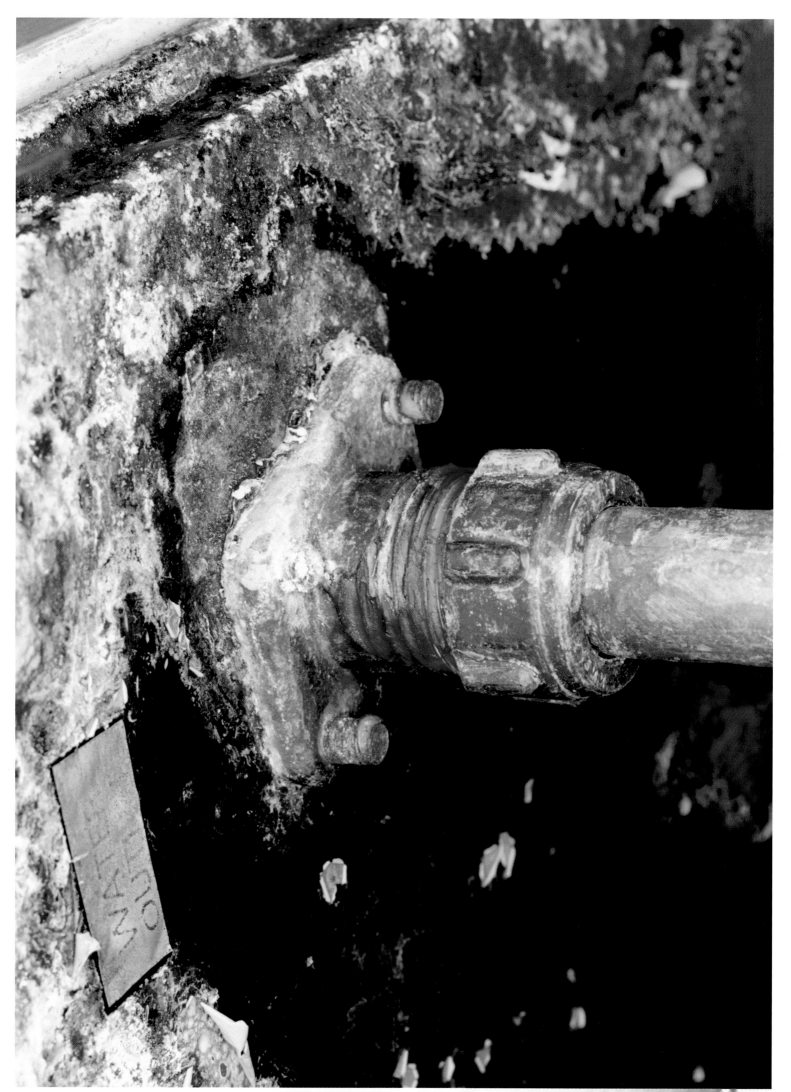

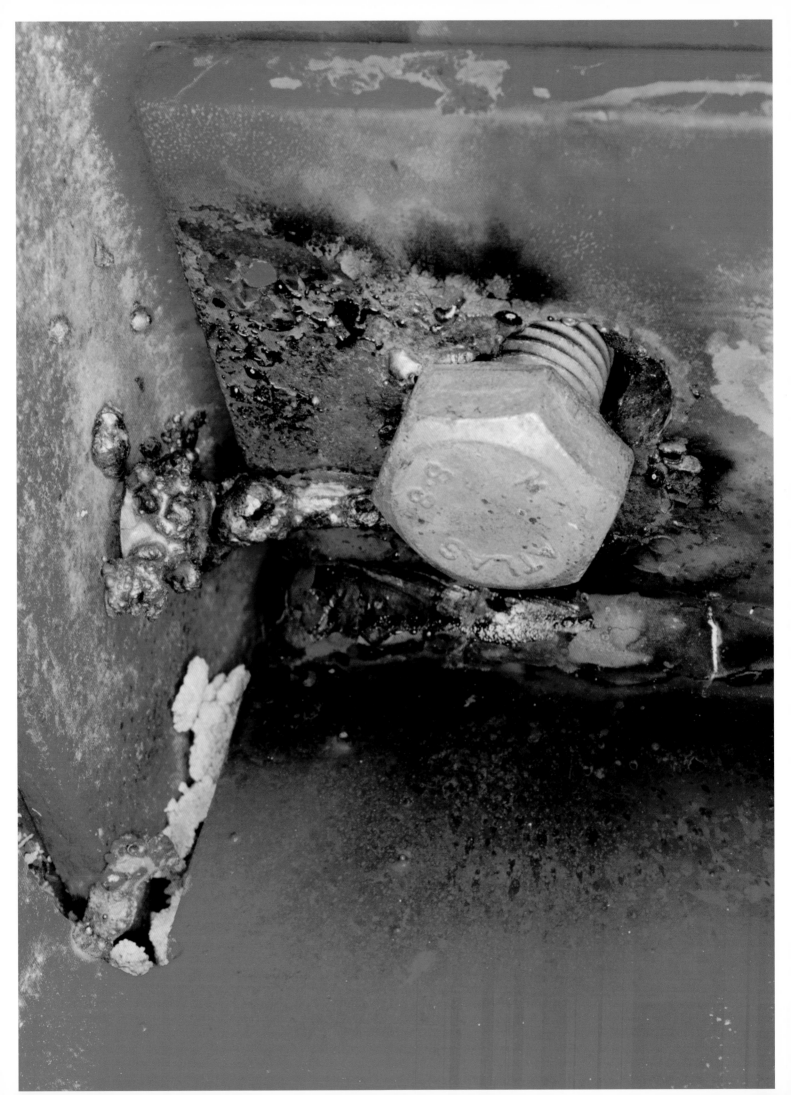

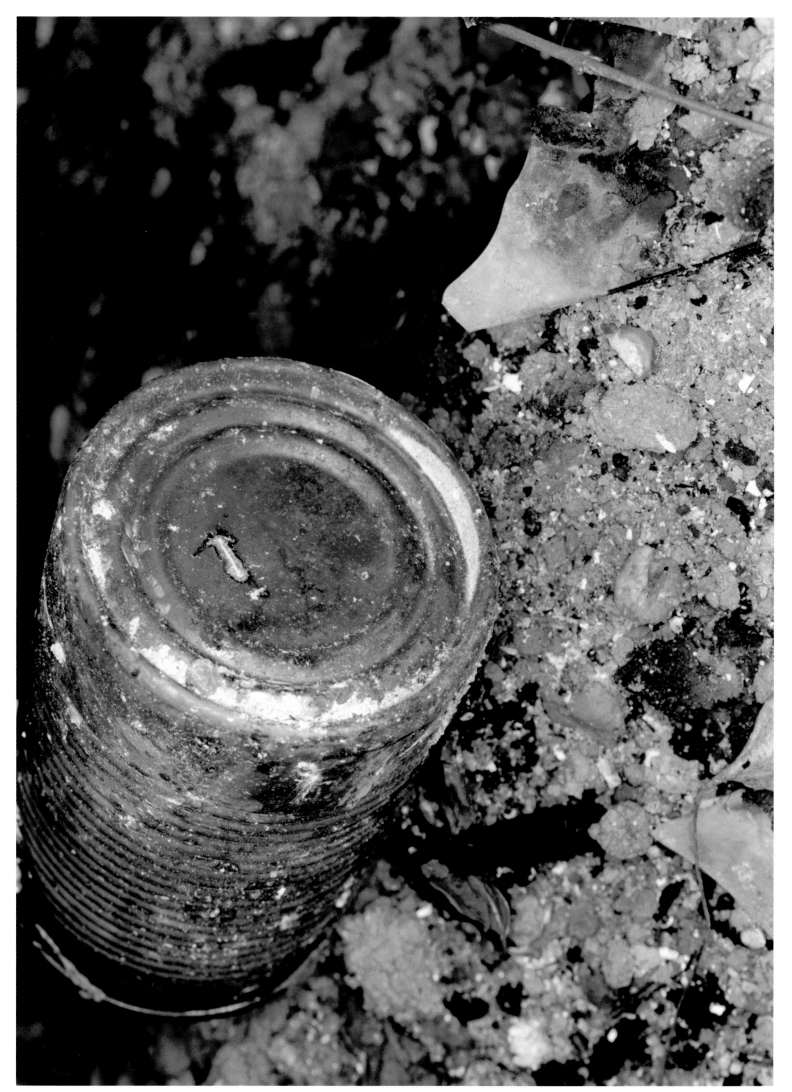

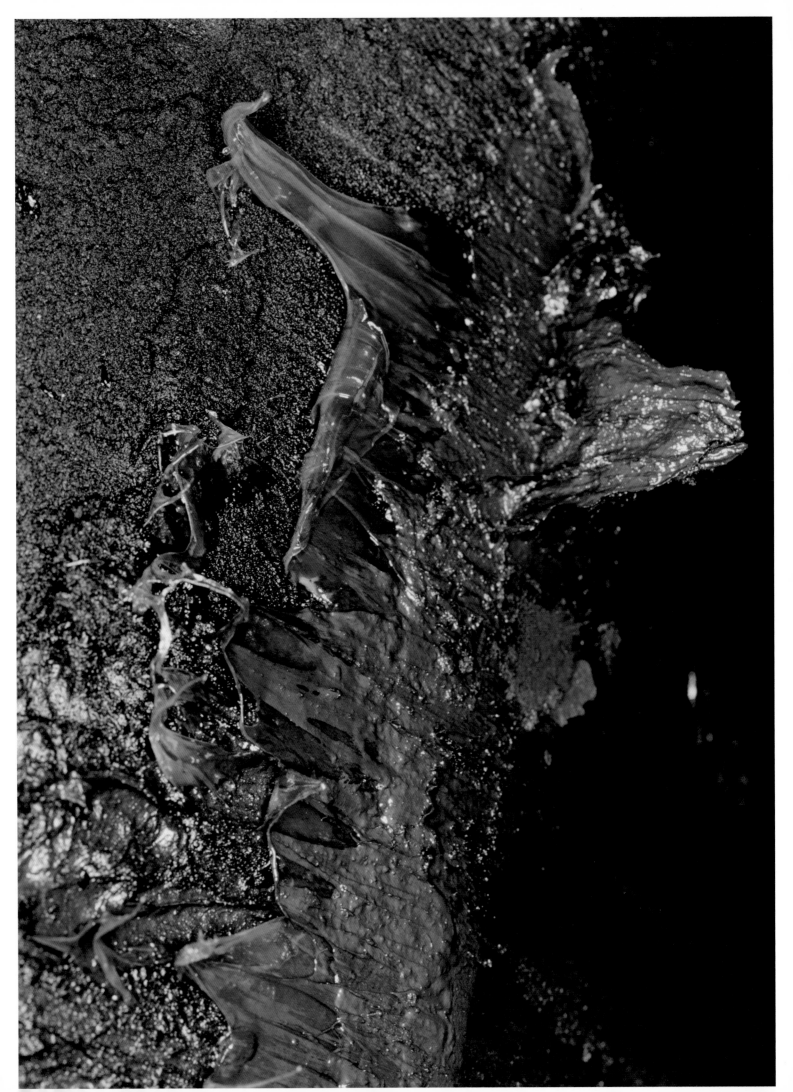

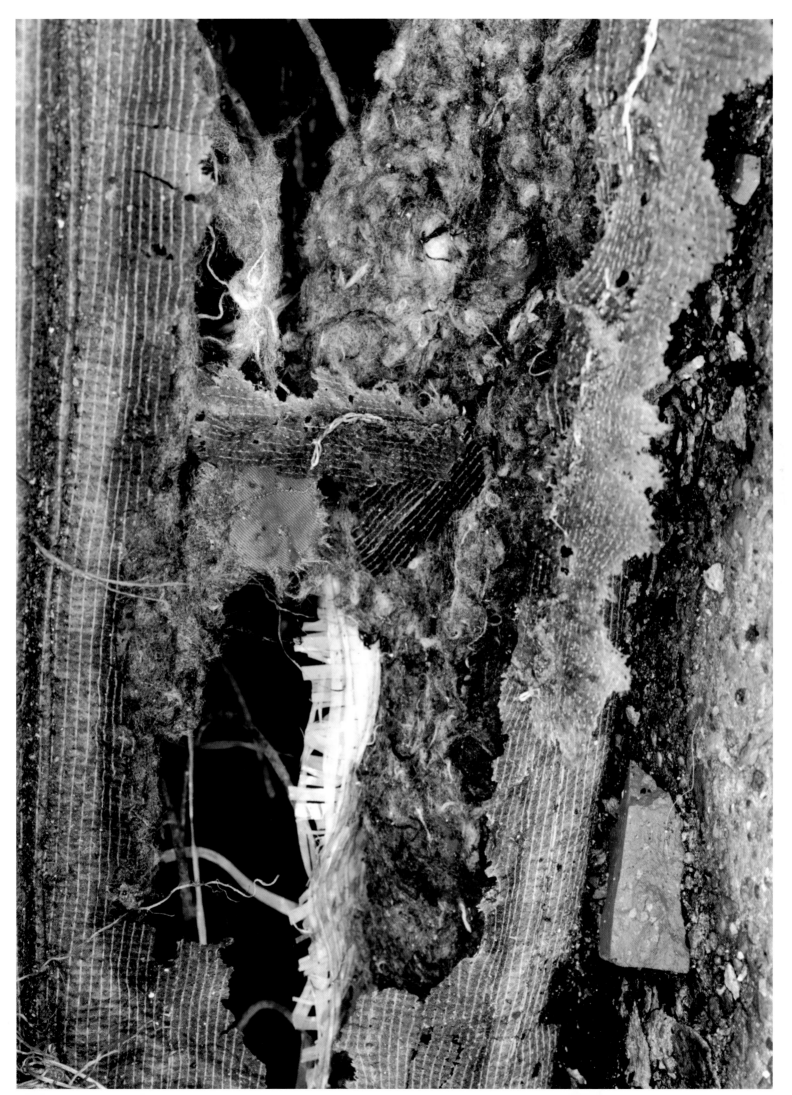

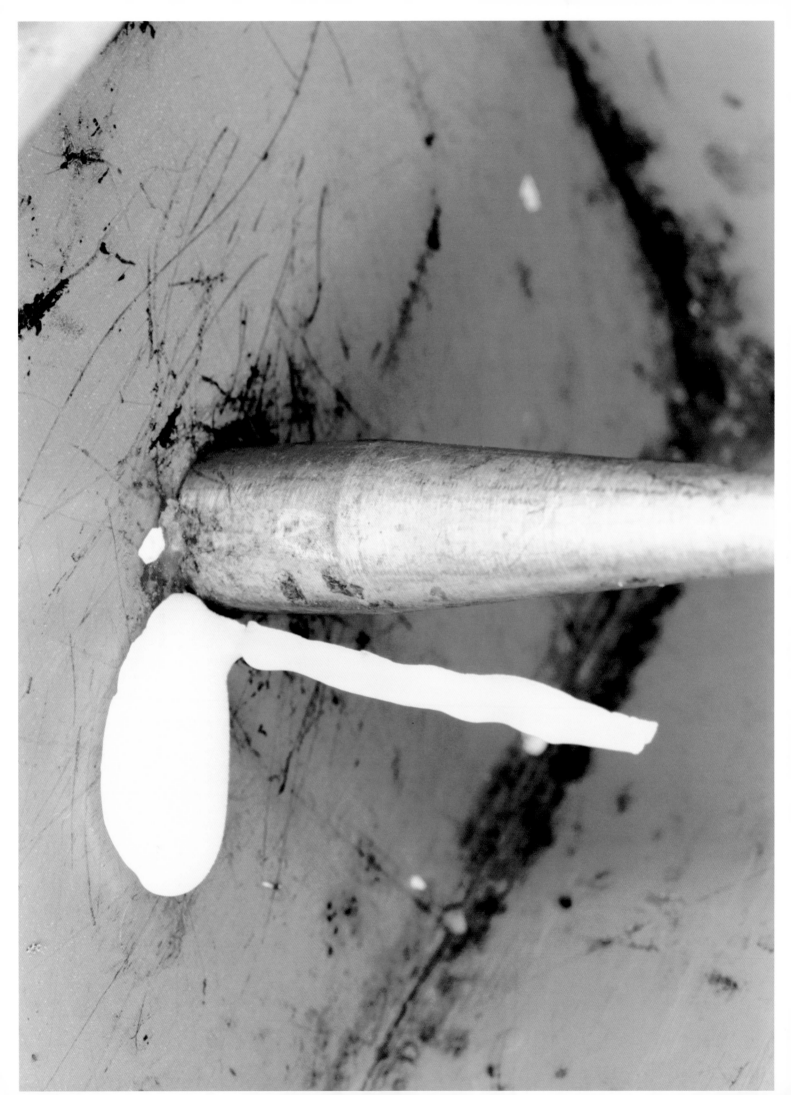

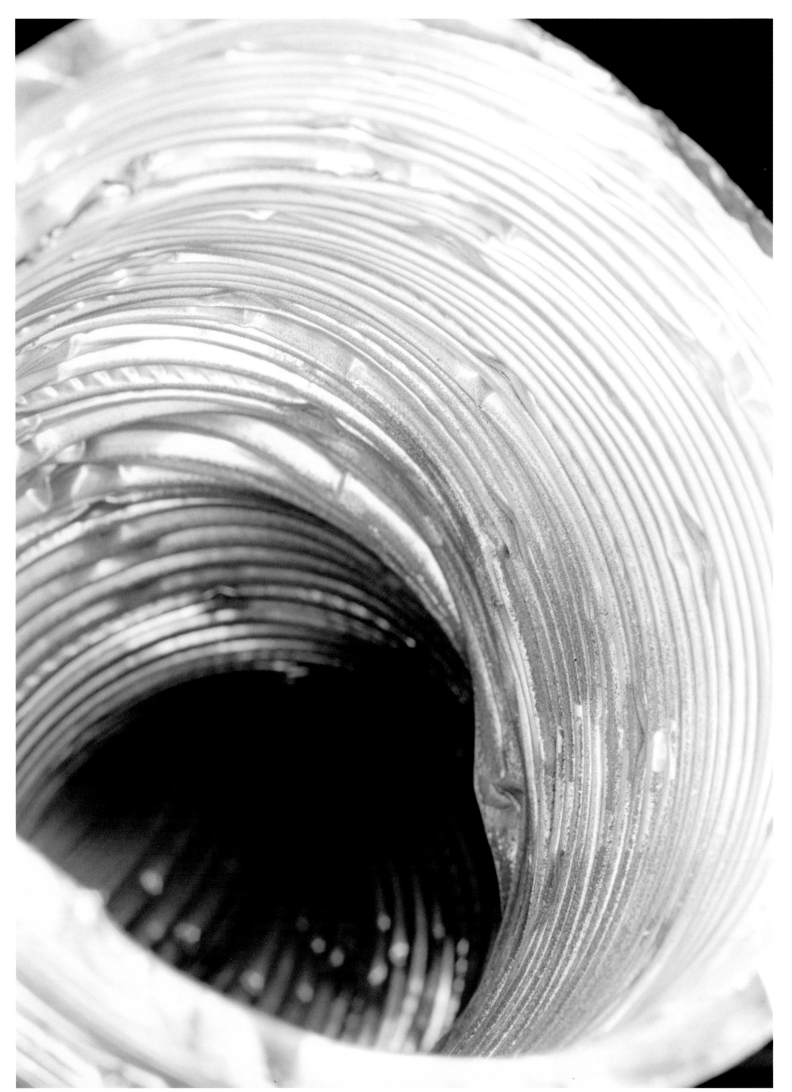

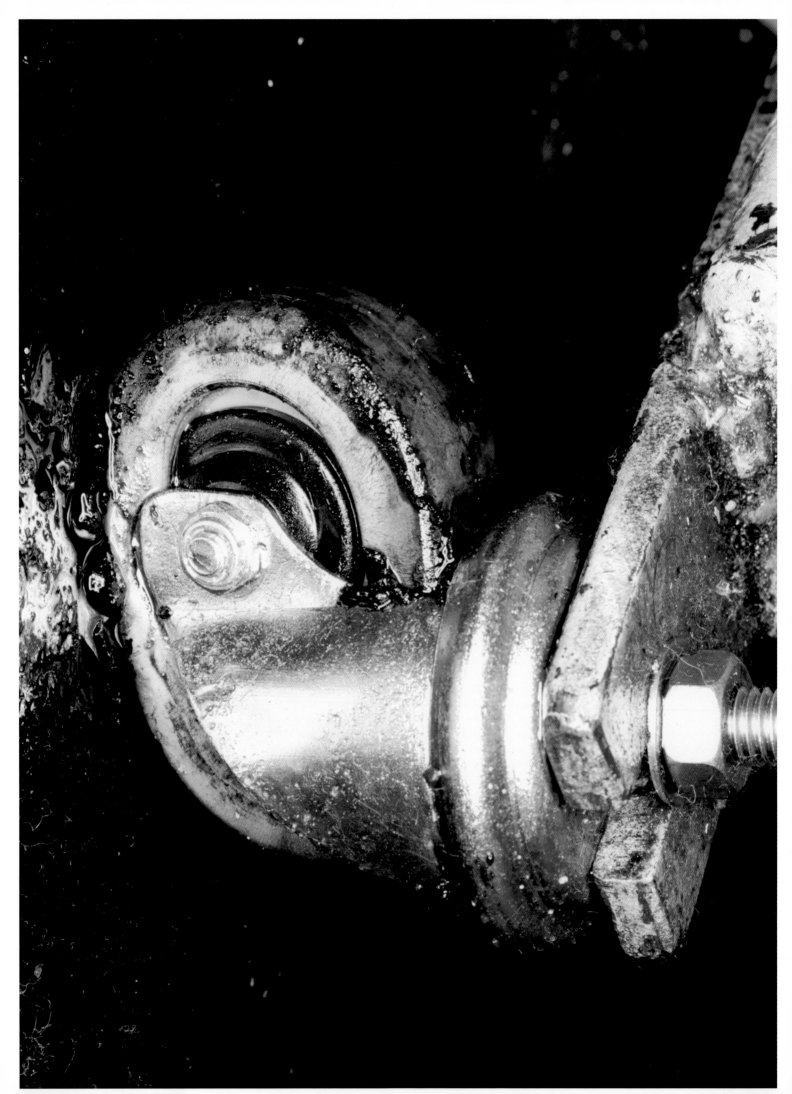

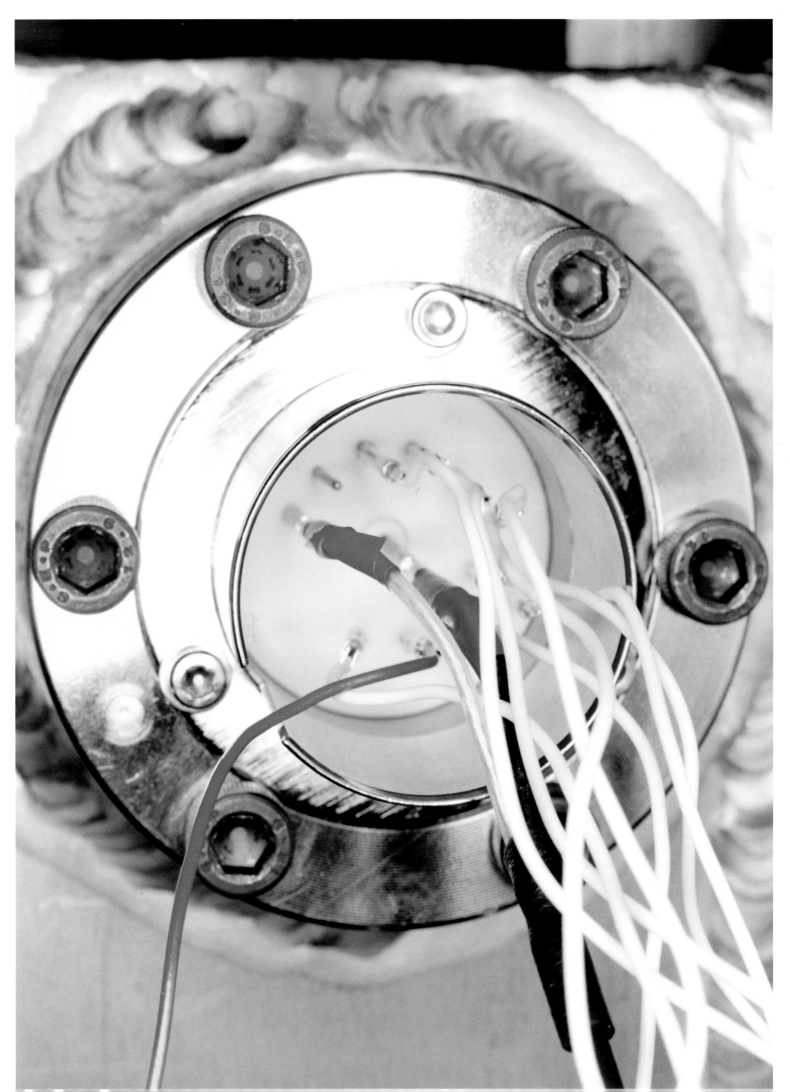

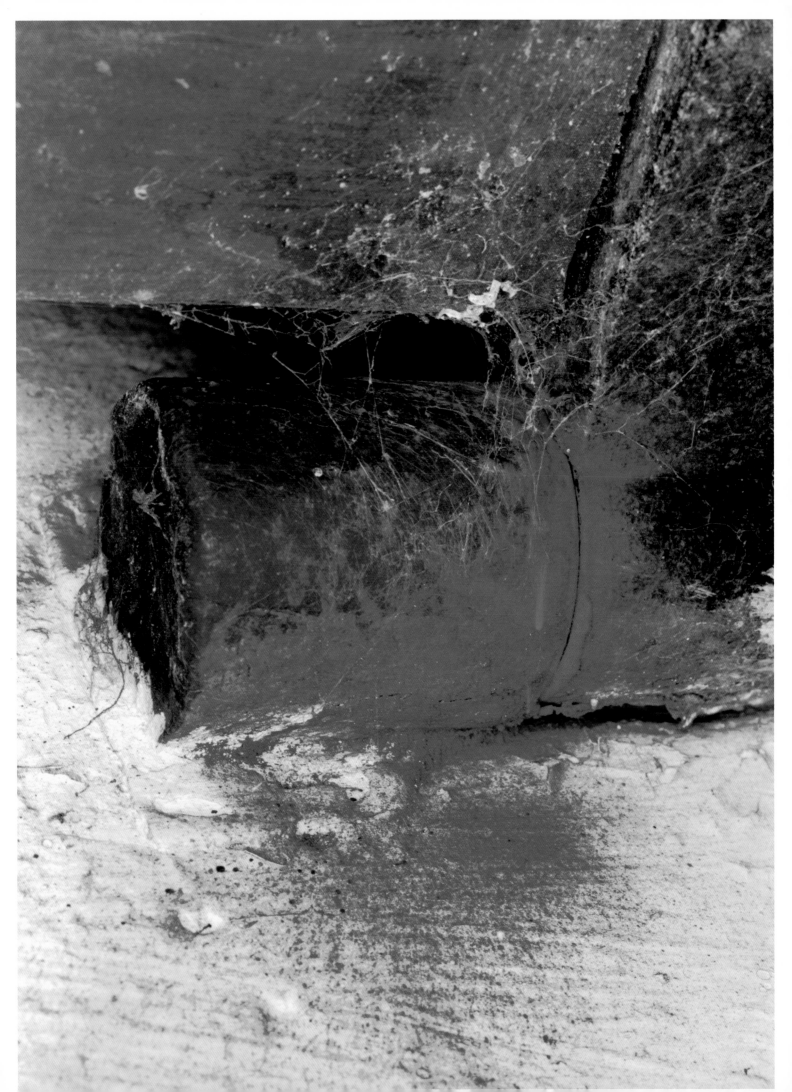

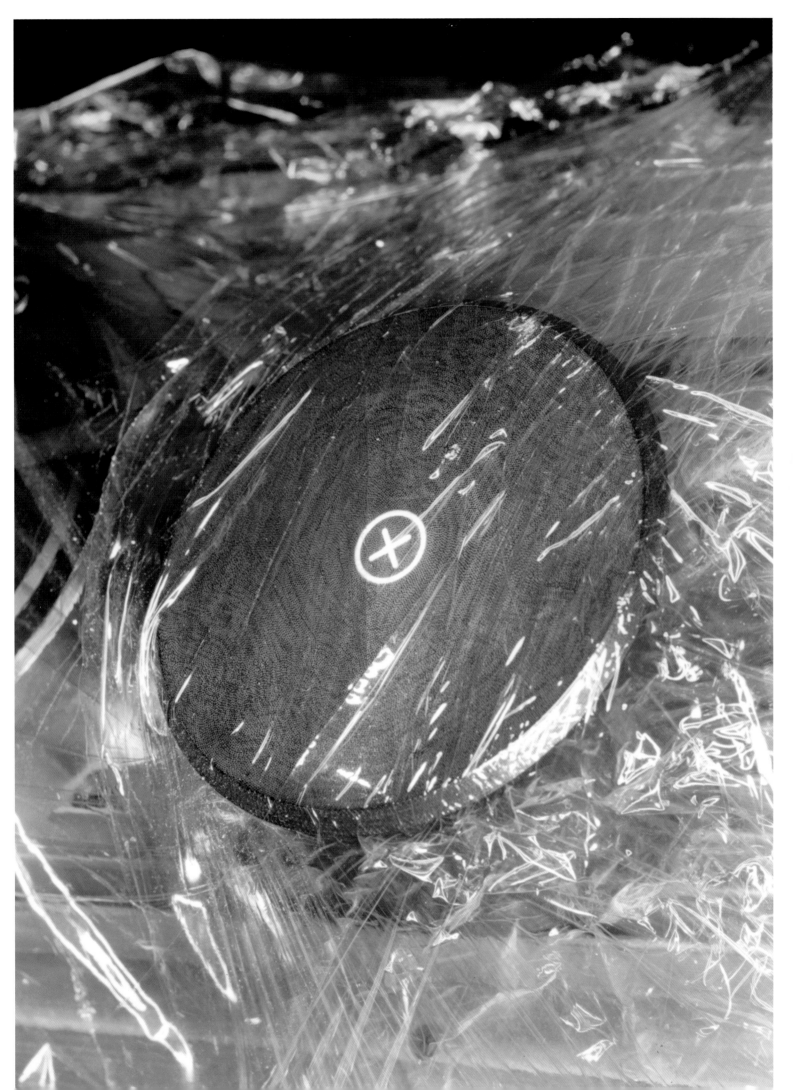

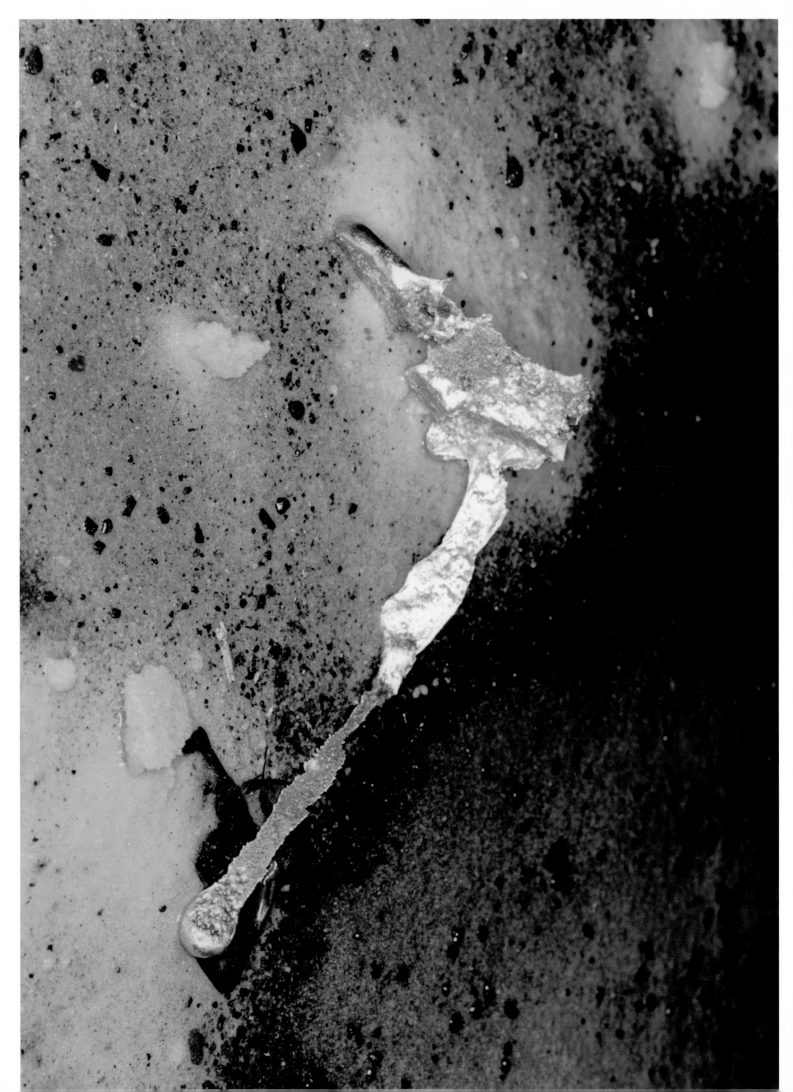

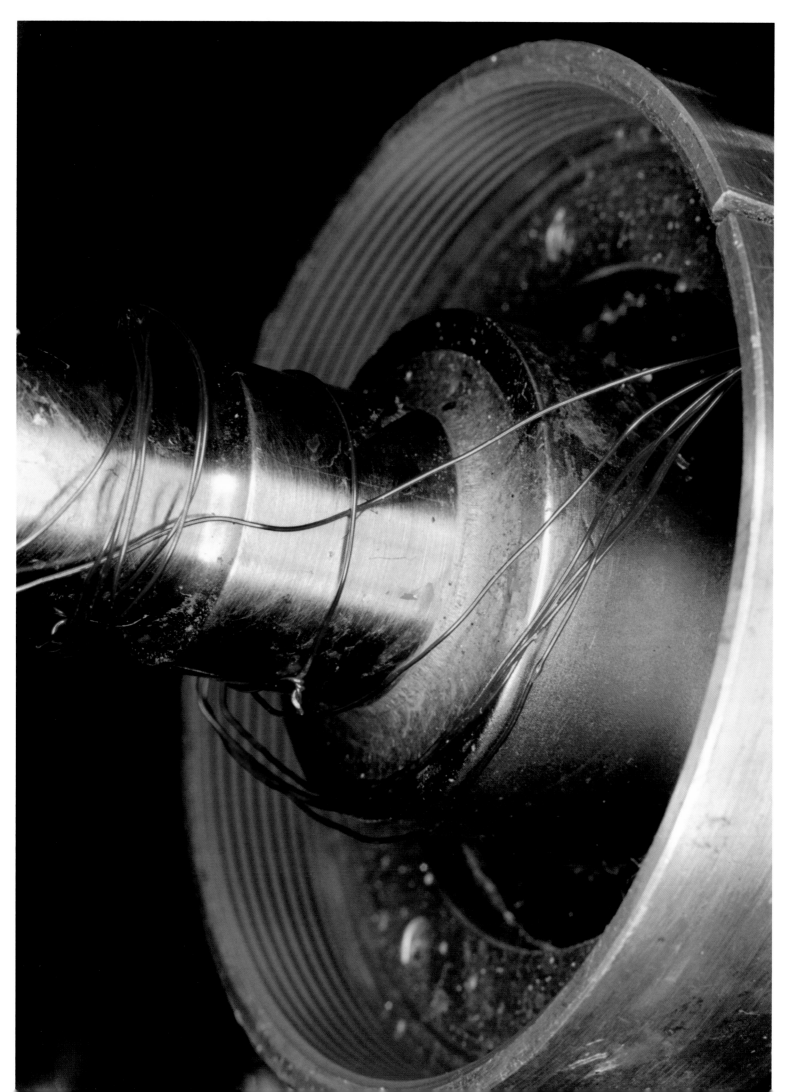

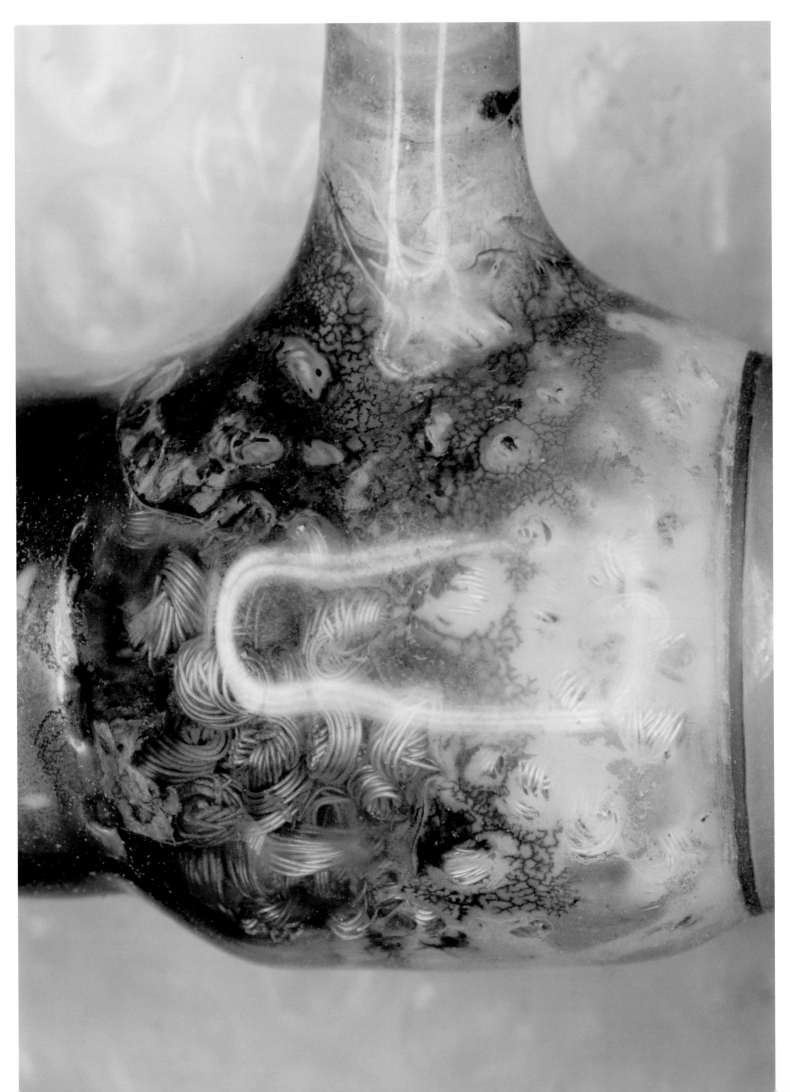

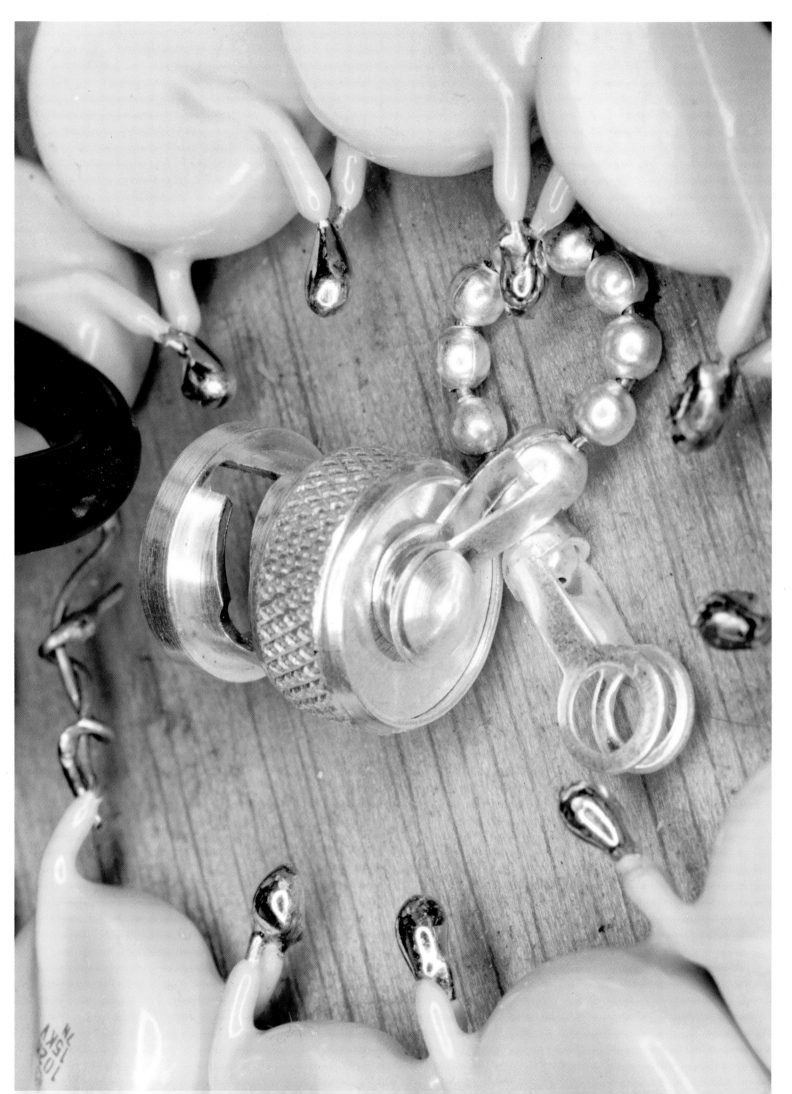

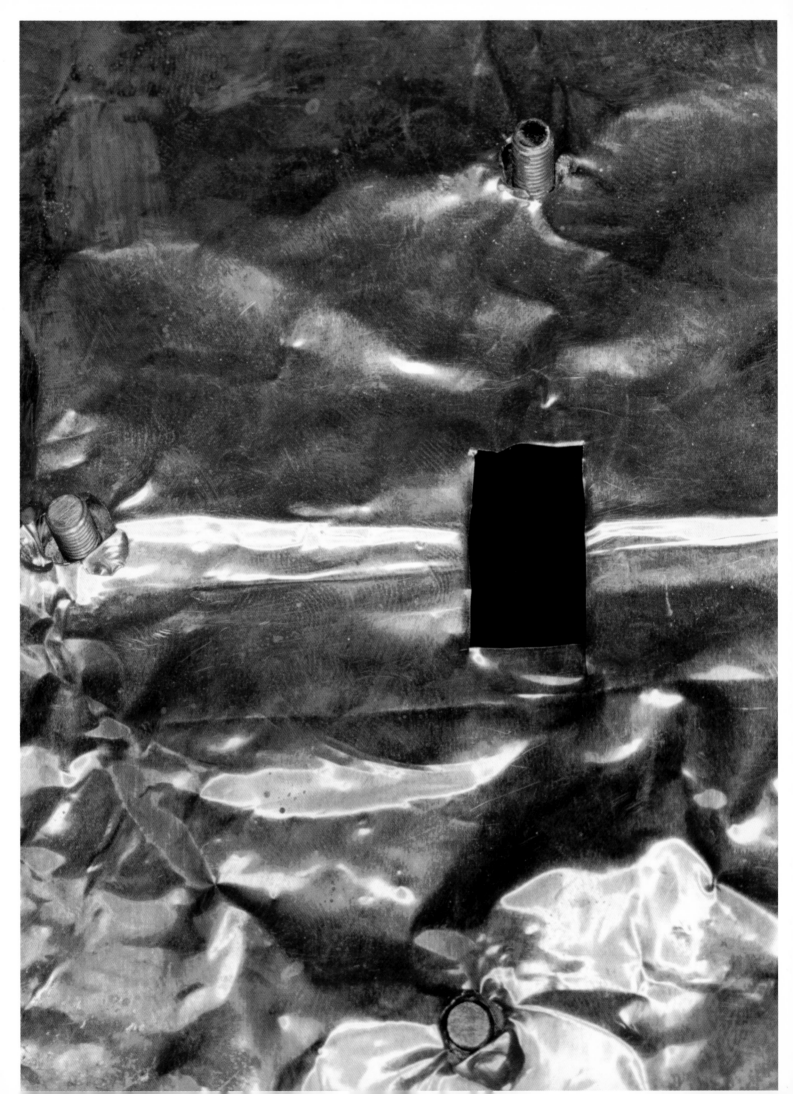

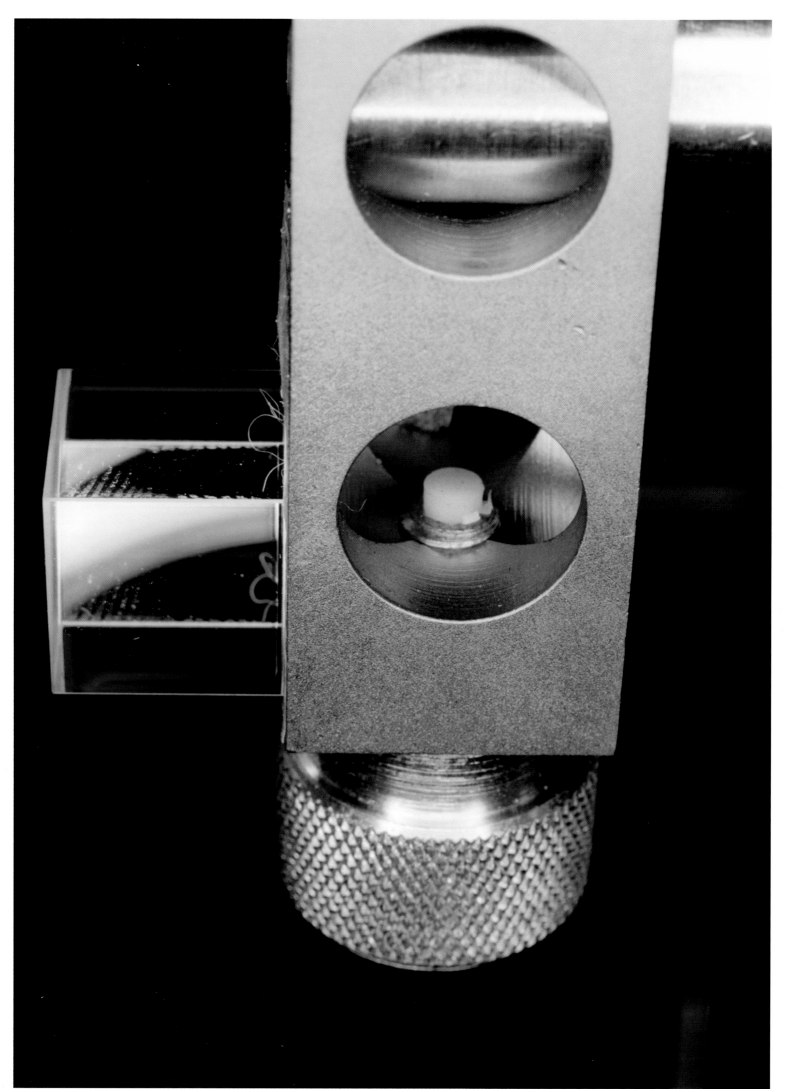

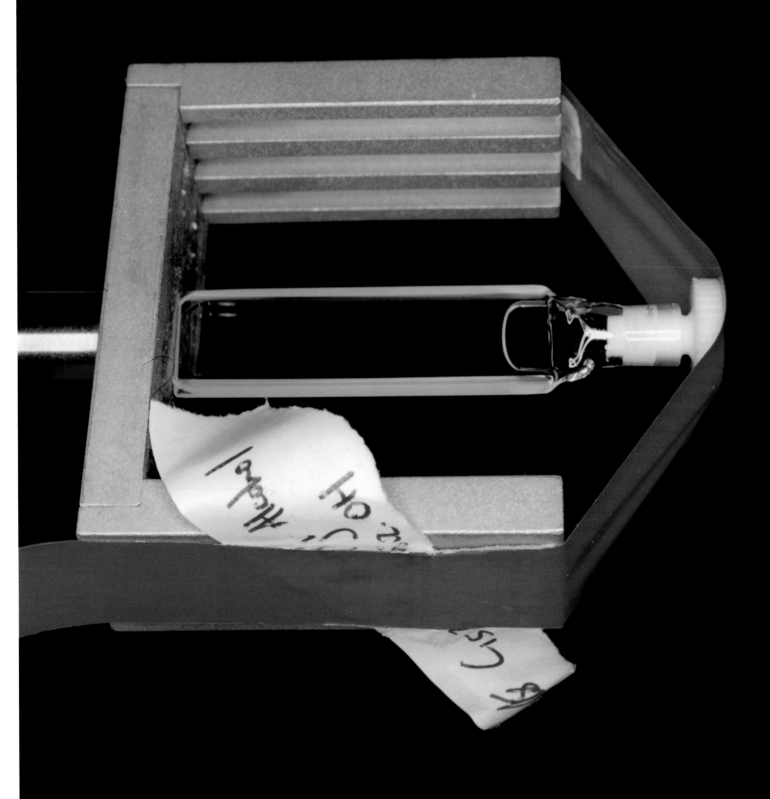

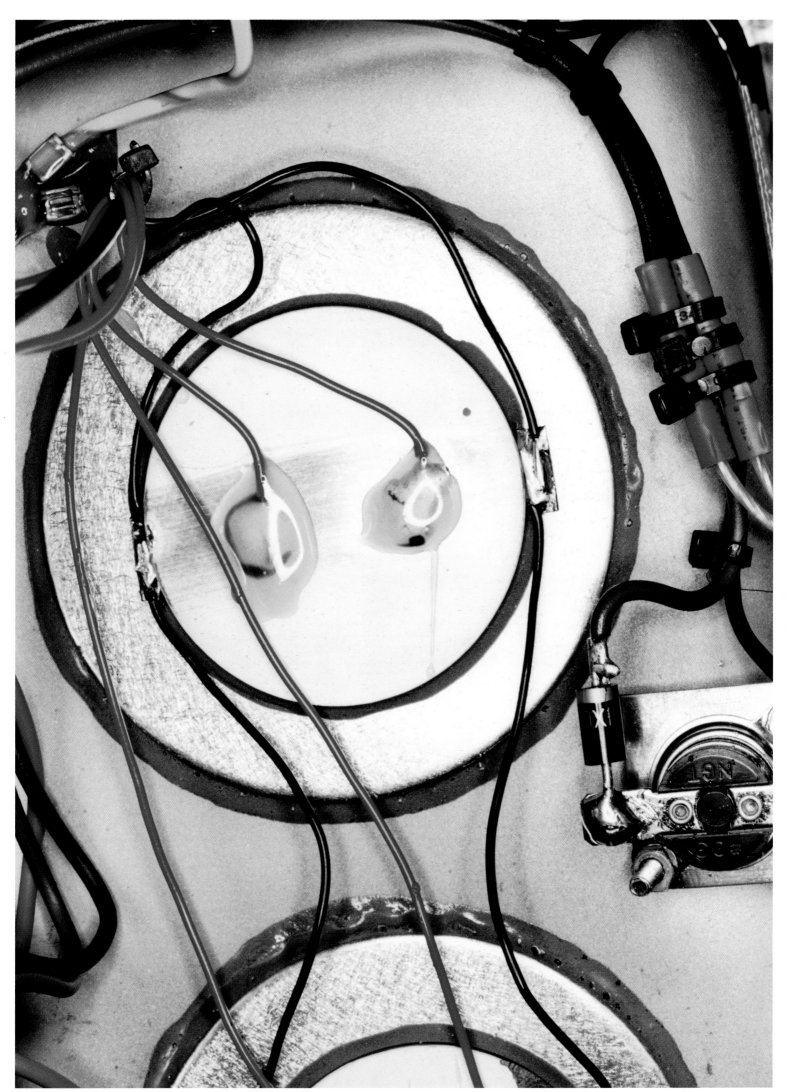

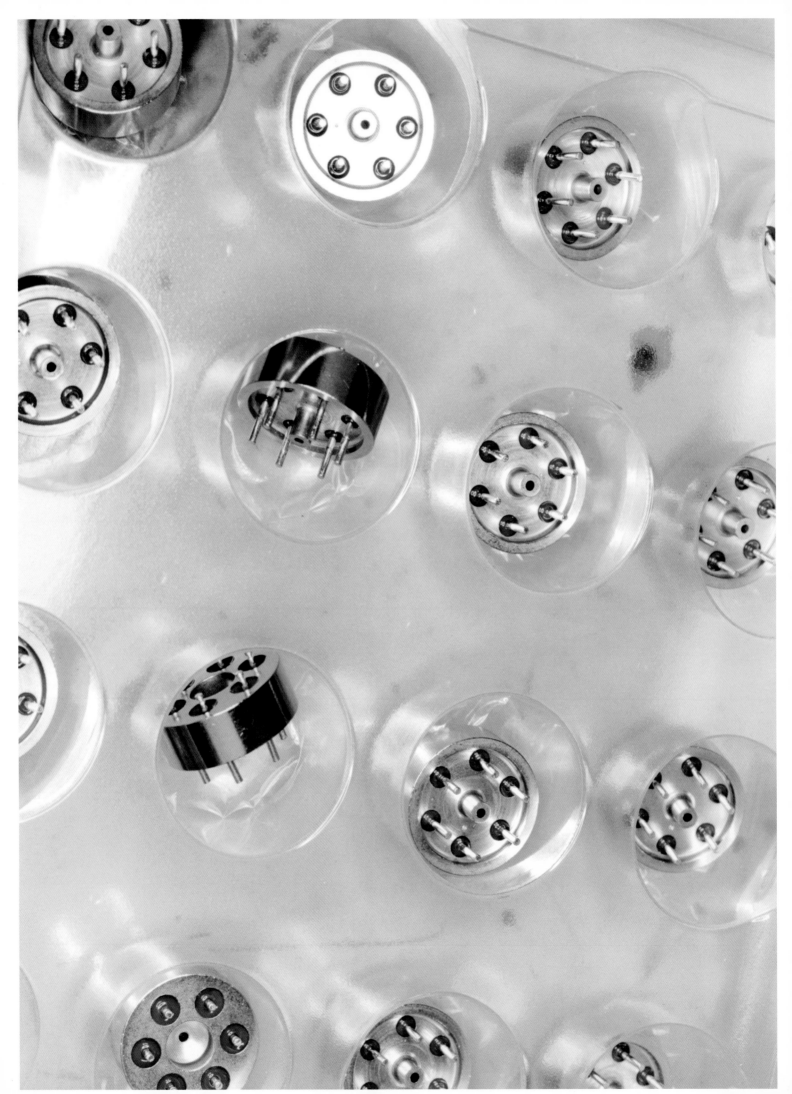

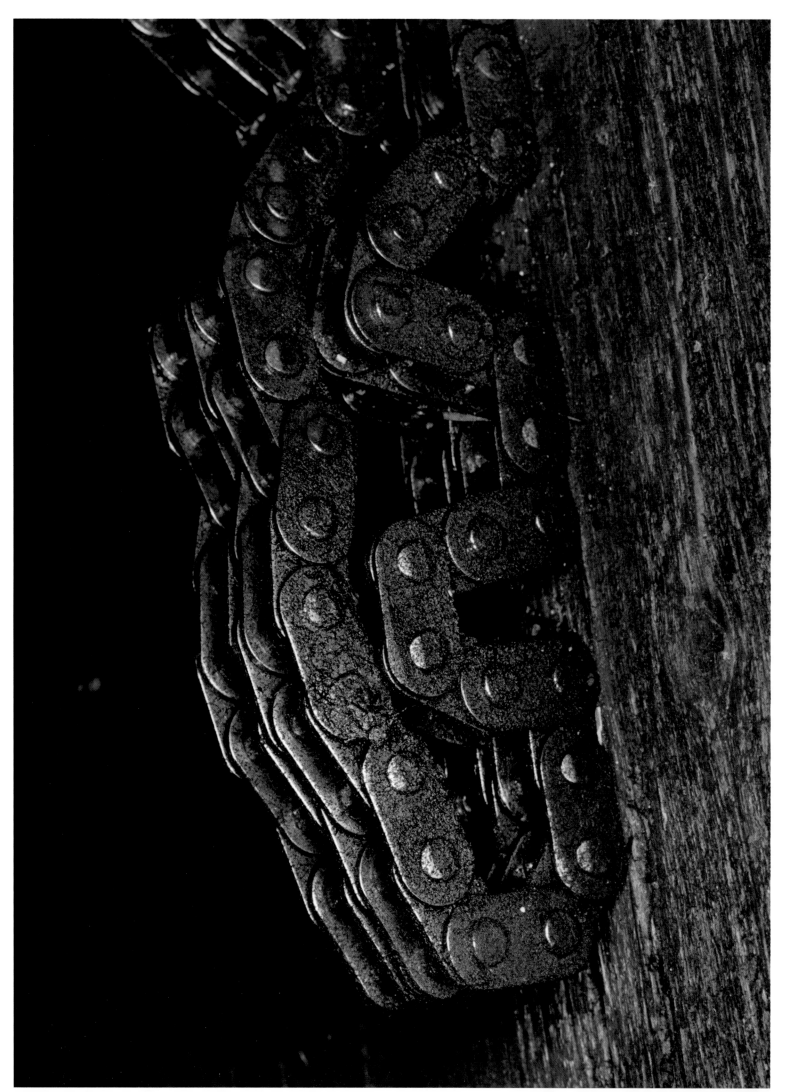

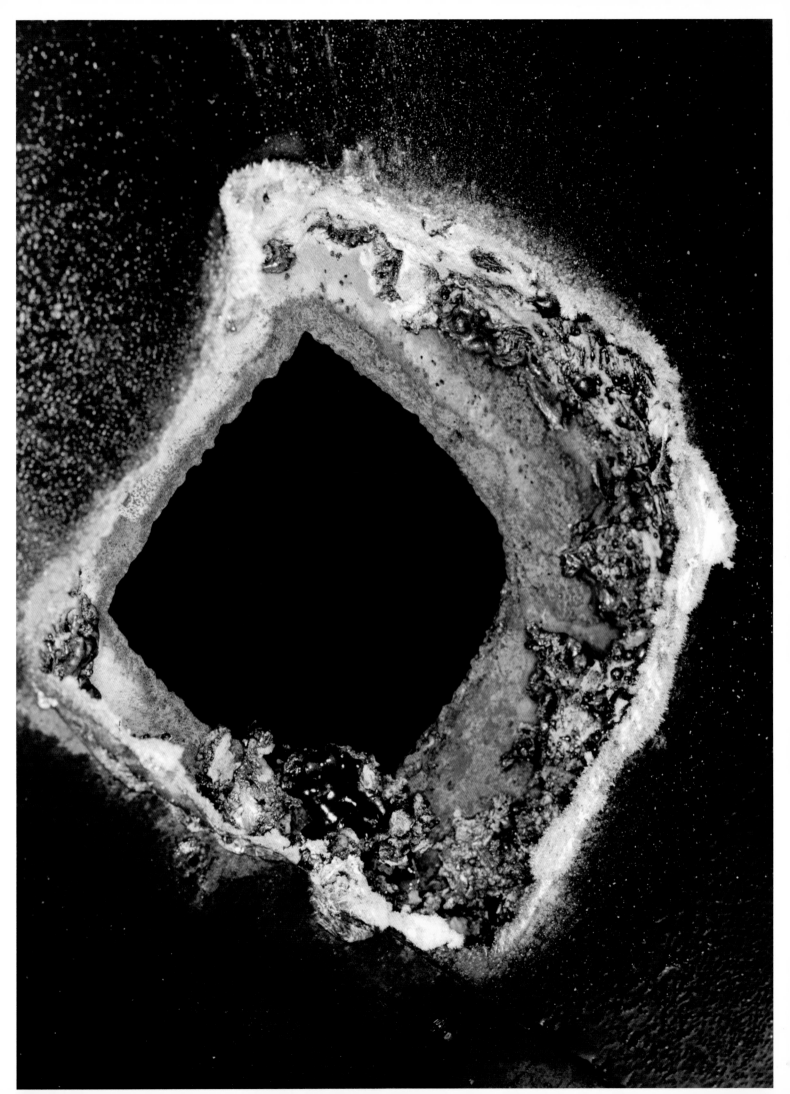

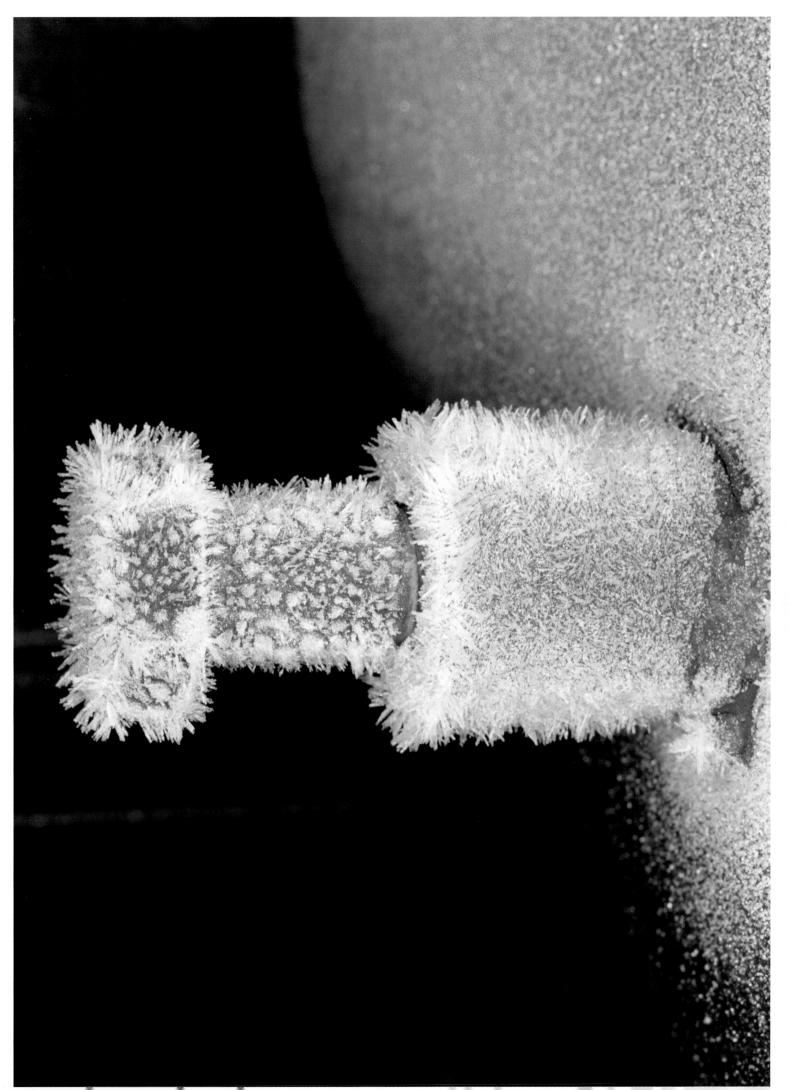

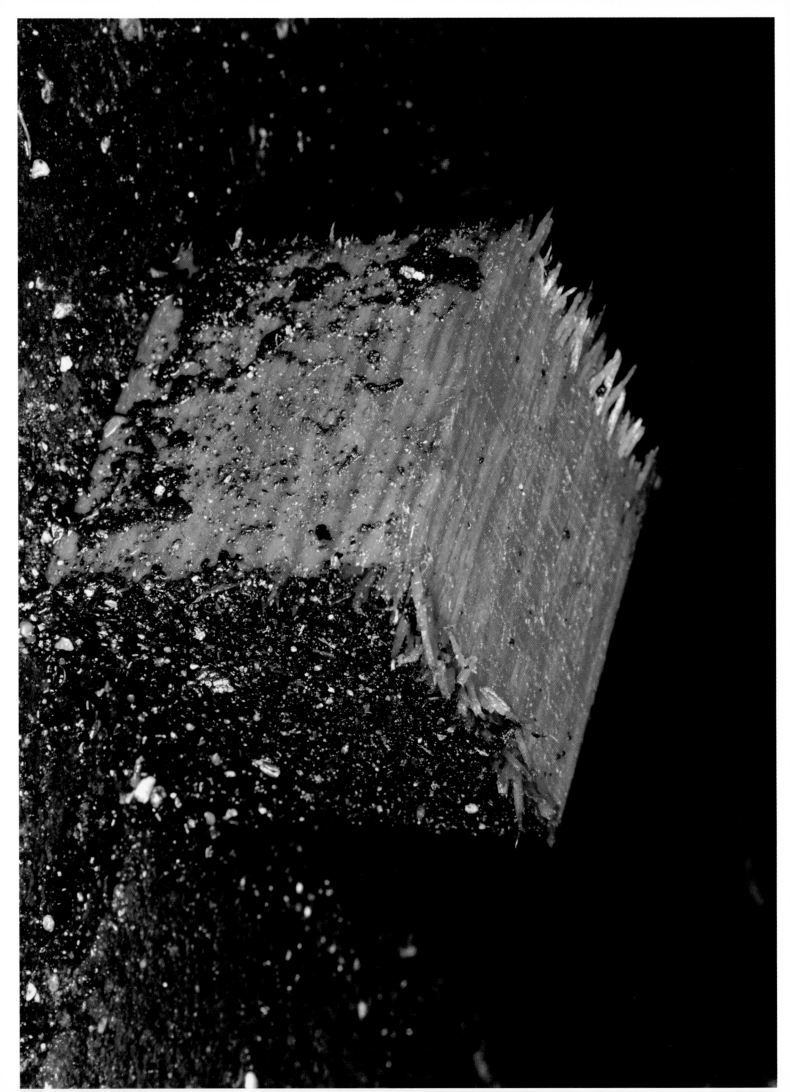

Peter Fraser
Born 1953
Lives and works in London

One-Person Exhibitions

2002 The Photographers Gallery, London, England
1999 213 Gallery, Paris, France
1997-1998 Deep Blue, Viewpoint Gallery, Salford, England, Ffotogallery, Cardiff, Wales; Cambridge
 Darkroom, Cambridge, England, Tullie House, Carlisle, England
1996 Deep Blue, Stephen Friedman Gallery, London, England
1995 Ice and Water, St Louis Museum of Art, Missouri, USA
1994 Ice and Water, James Hockey Gallery, Farnham, England
1993 Ice and Water, Cornerhouse, Manchester, England
1989 Triptychs, Interim Art, London, England
1988 Towards an Absolute Zero, Watershed, Bristol, England, Plymouth Arts Centre, Plymouth,
 England, Ffotogallery, Cardiff, Wales
1987 Spectrum Galerie, Sprengel Museum, Hanover, Germany
1986 Everyday Icons, The Photographers Gallery, London, England, Photo Gallery Hippolyte,
 Helsinki, Finland
1985 12 Day Journey, Harris Museum and Art Gallery, Preston, England, Axiom, Cheltenham, England
1984 New Colour, Oldham Art Gallery, Oldham, England, Arnolfini, Bristol, England
1982 The Flower Bridge, Impressions Gallery, York, England

Selected Group Exhibitions

2001 Nothing, Northern Gallery for Contemporary Art, Sunderland, England; Contemporary Art
 Centre, Vilnius, Lithuania, Rooseum, Malmo, Sweden
1994 Institute of Cultural Anxiety: Works from the Collection, Institute of Contemporary Art,
 London, England
1992 Mehr Als Ein Bild, Sprengel Museum, Hanover, Germany
1991 Pamela Golden, Marcus Hansen, Peter Fraser, Interim Art, London, England
1989 Foto Biennale Enschede, Rijksmuseum Twenthe, Enschede, Holland
 Through The Looking Glass, Barbican Art Gallery, London, England
 Recent Acquisitions, Hayward Gallery, London, England
1988 A British View, Museum for Gestaltung, Zurich, Switzerland
 Towards a Bigger Picture, Victoria and Albert Museum, London
1987 Inscriptions and Incidents, P.R.O.K.A, Ghent, Belgium, toured to Luxembourg,
 Italy and Germany
1986 I Hate Green, Ffotogallery, Cardiff, Wales
 New British Documentary, Museum of Contemporary Photography, Columbia College, Chicago,
 Illinois, USA
1985 A Sense of Place, Interim Art, London, England
 Image and Exploration, The Photographers Gallery, London, England
 Young European Photographers, Frankfurter Kunstverein, Frankfurt, Germany

Selected Publications

2001 Nothing, August/Northern Gallery For Contemporary Art, Sunderland, England
1999 Peter Fraser, Galerie 213, Paris, France
1997 Deep Blue, Viewpoint Photography Gallery, Salford, England/Ffotogallery, Cardiff,
 Wales/Tullie House, Carlisle, England/Cambridge Darkroom Gallery, England
1995 Olivia Lahs-Gonzales, Currents 63, St. Louis Art Museum, Missouri, USA
1993 Jeremy Millar, Ice and Water, James Hockey Gallery, Farnham, England/Cornerhouse,
 Manchester, England
1988 Rupert Martin (ed), Towards an Absolute Zero, Zero Press, Bristol, England
 Rupert Martin (ed), Two Blue Buckets, Cornerhouse, Manchester, England
1987 Ian Jeffrey, Inscriptions and Inventions, British Council
1986 Susan Beardmore, I Hate Green, Ffotogallery, Cardiff, Wales

Selected Bibliography

1995 Robert Duffy, 'Fraser's Different Focus', St. Louis Post-Dispatch, 20 August
1994 Ian Jeffrey, 'Peter Fraser', Untitled Magazine, Spring, p. 17
1993 Mark Durden, 'Ice and Water', Creative Camera, December, p. 42
1989 David Mellor, 'Coincidenta Oppositorum', Interim Art, London
 Sue Hubbard, 'Peter Fraser – Triptychs', Time Out, 26 July
 Mary-Rose Beaumont, 'Peter Fraser', Arts Review, 28 July, p. 42
1988 Ian Jeffery, 'British Photography Flourishes', Camera Austria, pp. 58-61
 Ian Jeffrey, 'Unrepentant Roses', Creative Camera, December, p. 34
 David Mellor, 'Romances of Decay', Aperture, New York, Autumn
1986 William Bishop, 'Photographs by Peter Fraser', Creative Camera, May, pp. 18-25

Collections

Arts Council of England, London, England
The Arthur Andersen Art Collection, London, England
The British Council, London, England
Fotografie Forum, Frankfurt, Germany
Manchester Art Gallery, England
Morgan Stanley, London
North West Arts Association, Manchester, England
Oldham Art Gallery, England
St. Louis Museum of Art, St. Louis, Missouri, USA
Siemens Collection, Munich, Germany
National Museum of Photography, Film and Television, Bradford, England
The Victoria and Albert Museum, London, England
Washington University Art Gallery, St. Louis, Missouri, USA
Private Collections in Britain, France, Belgium and USA

Many of the photographs in this book were made at the Physics and Applied Physics Department at the University of Strathclyde, Glasgow, assisted by a generous grant from the Engineering and Physical Engineering Council (EPSRC) made in April 1999. My thanks to the Council and to the University of Strathclyde Physics Department for their unqualified support and enthusiasm for the project. The award and the opportunity to work in the Physics Department would not have been possible without the energy and commitment of Dr. Dino Jaroszynski, and Dr. Brian McNeil, to whom I will always be indebted.

I would also like to extend my thanks to Jeremy Millar for his sustained and rigorous support for my work over a period of time.

Finally, this book would not have been possible without the vision and consistent support of Michael Mack, with whom it has been inspiring to work, and to whom I offer my deepest thanks.

Peter Fraser, London 2002
www.peterfraser.net

First edition 2002

Photography Peter Fraser
Edited and designed by Michael Mack

Copyright © 2002 Peter Fraser for all images
Copyright © 2002 Steidl Publishers for this edition

Scans done at Steidl's digital darkroom
Printing by Steidl, Göttingen

Steidl
Düstere Strasse 4
D-37073 Göttingen
Phone +49 551 49 60 60
Fax +49 551 49 60 649
E-mail mail@steidl.de
Orders can be placed directly at our
publishing house or via the internet

ISBN 3-88243-729-4
Printed in Germany